GREAT PAINTINGS
OF THE
Old American West

BY PATRICIA JANIS BRODER

FOREWORD BY

FRED MYERS
Director, Thomas Gilcrease Institute
of American History and Art

ABBEVILLE PRESS · PUBLISHERS · NEW YORK

All paintings reproduced by permission of the

Thomas Gilcrease Institute of American History and Art

of Tulsa, Oklahoma

Library of Congress Catalog Card Number: 79-2401
ISBN 0-89659-068-2

Printed and bound in the United States of America.

CONTENTS

FOREWORD

by Fred Myers

Director, Thomas Gilcrease Institute
of American History and Art

The collection of the Thomas Gilcrease Institute of American History and Art is not as well known as it deserves to be. With the exceptions of the diligent scholar, the fortunate Tulsa sixth-grader brought to the Institute for a visit required by his school, or the enterprising tourist who senses there is a unique institution close to his interstate road and breaks his cross country trip to visit the Gilcrease galleries—except for such people, few know of the riches of the Gilcrease Institute. Yet as the pictures in this book indicate, a significant view of the American experience is available through the Gilcrease collection.

How did the collection come about? It came about, as is the case with many great collections, through the vision and tenacity of one person, Thomas Gilcrease. A successful oil entrepreneur as a very young man, Thomas Gilcrease bought his first painting in 1912. A sober man who kept his own counsel, Gilcrease soon developed a grand scheme: his collection would document the experience of man in the Northern Hemisphere of the New World.

Few collectors were paying attention to American things then, so Gilcrease forged his own network of contacts—sometimes buying in New York, sometimes in Europe where there were caches of the earliest material, sometimes directly from contemporary artists, and occasionally buying other large private collections in their entirety. By the time the collection was turned over to the City of Tulsa—part of it in 1955, the remainder on the death of Thomas Gilcrease in 1962—the claim could legitimately be made that the Gilcrease purchases did tell the American story with some degree of completeness.

The roughly 65,000 anthropological items in the collection illustrate Indian modes of life before and after the coming of Europeans. The 85,000 manuscripts, documents, and books detail the establishment of white man's governments not only in what is now the United States, but also in the places that became Canada and Mexico. The 8,000 paintings and sculptures illustrate the spread of European modes with particular explicitness, of course, in the exploration and taming of the country west of the Mississippi River.

The 484 Catlin works, the 136 Alfred Jacob Millers, the 825 Morans portray, in a way that nothing else can, the life and times of the West when it was new to Europeans; and the Remingtons, Russells, and Schreyvogels establish the cowboy-calvary-Indian myth; and the Taos painters document the Spanish-Anglo-Indian culture of the Southwest. The list could go on, but the scope has been suggested.

A man of few public words, Thomas Gilcrease once said, "A man must leave a track." The Gilcrease collection is indeed a track of unique worth. It is a path for everyone, a path that leads to a fuller comprehension of American history and culture.

INTRODUCTION

Since the first half of the nineteenth century, generations of painters have chosen as the principal subject of their art, the people, events, and land of the American West. Today paintings of the old West are among America's most valuable cultural treasures. The art of the old American West is basically historical. It is a narrative art, which tells the story of the impact of successive waves of trappers, traders, pioneers, adventurers, and soldiers on the land and on the original inhabitants of the West. Paintings of the old American West document the life of the Indian people before the arrival of the Anglo-European population in the trans-Mississippi West and the changes in Indian life and culture in the years that followed the establishment of trading posts, forts, and settlements. These paintings tell the story of armed conflicts with the Indians and of the destruction of many Indian cultures. They document the building of new communities in the West and celebrate the success of traders and prospectors who turned West to seek their fortunes. Many paintings narrate the story of the development and changes of the means of travel and commercial transportation across the West—the wagon train, the freighter, the stagecoach, the pony express, and the railroad. Paintings of the old West illustrate the evolution of the American cowboy from the Spanish vaquero to the growth of the cattle industry, the life of the lonely cowhand, and the adventures of the rough-riding bronco buster. Artists, following a tradition of portrai-

ture, have recorded the likenesses of Indian leaders and military figures, frontiersmen and folk heroes, lawmen and outlaws. Through the years the American West as a subject for painting has had a magnetic attraction for both artist and audience.

The American West is celebrated throughout the world as the land of the Indian and the cowboy. The American West is the land of the hero: and the Indian, the cowboy, the cavalryman, and the pioneer are all heroic figures of the West. The Indian, whose people lived on the American continent for thousands of years, is the ultimate heroic subject of such paintings. Generation after generation, artists have been inspired by a sense of mission to record the vanishing world of the Indian and have painted the religious rituals, routines of daily life, hunting expeditions, sporting competitions, intertribal warfare, and open conflicts with the white man. The heroes of the transformation of the West from wilderness to frontier to white man's civilization were the traders, explorers, pioneers, cowboys, and cavalrymen. Artists have recognized their mission as chroniclers of the changing West, and they have documented the events in the great pageant of the settlement and industrialization of the West—Indian treaties signed and broken, wars with the Indians, and confinement of Indians to reservations. The procession of wagon trains crossing the continent from the Mississippi River to the Pacific coast, the building of the transcontinental rail-

road, the growth of the cattle industry, and the discovery of gold and mineral wealth in the West all heralded the Americanization of the West.

The first artists to paint the frontier were the artist-explorers. They journeyed to the West, some as solitary wanderers, others as official artists of sporting, survey, and military expeditions. All recognized their mission to record the Indian world they witnessed before it was irrevocably changed by the settling of the West. In succeeding decades artists traveled West and, inspired by the work of the first generation of Western painters, painted images of Indian and pioneer life. By the late nineteenth century, artists recognized that irreversible changes had taken place. They realized they would be the last generation with the chance to paint Indian culture in its final stages of transition from a self-sufficient, independent culture to a defeated one, dependent on the white man. They painted the final days of the buffalo hunt and Indian councils with the white man and the early days of the Indians' confinement to reservations. In contrast, the Taos artists painted scenes of life in a Pueblo village, which had remained virtually unchanged through the centuries. The painters who arrived in Taos at the turn of the century were amazed to find a center of Indian civilization that was relatively undisturbed, despite over three centuries of contact with European civilization.

Paintings of the old West have great value, not only as a pictorial record of the American land and people, but as visual testimony to the beliefs and values of the artists and their audiences. From the earliest artistic efforts to document the Indian world and the frontier to contemporary canvases, which depict the twentieth-century West, a unique pattern is evident. It is the union of realism and romanticism in paintings of the American West. Realism and romanticism, inextricably fused, characterize the American attitude toward the people, history, and land of the West. This pattern is mirrored in the art of the West, for in each decade artists have worked to achieve the perfection of realistic images to express their beliefs and ideals.

Although painters of the West based their work on personal experience and historical study, each generation was influenced by popular beliefs and legends. Western paintings combine the specific and the imaginative—objective reality and cultural myth. Artists of the West have endeavored both to document details of costume, artifact, and physiognomic likeness and to capture in their work a sense of the spirit of the West.

Western paintings combine accurate, historical documentation with a romantic vision, for both artist and audience insist on authenticity of detail and historical accuracy.

This duality of realism and romanticism can be seen in the stereotyped images of the land and people of the West that have persisted through the years. Despite a reverence for objective observation and accuracy of detail, the mythology of the West is clearly evident in the work of each generation of painters of the American West. Often the myths of the American West involved the reconciliation of conflicting images and values.

The Indian has been the subject of both anthropological and ethnological study and romantic idealization. In many nineteenth-century paintings Indians are painted as stereotyped aborigines in ethnologically accurate costumes. The Indian is viewed as a tragic hero, doomed to extinction by the rush of progress. He is romanticized as both savage and nature's nobleman—a threat to the march of civilization that must be destroyed and a child of nature living in harmony with the laws of nature. The Indian was simultaneously an obstacle to progress and a vanishing species of aborigines who understood how to live in harmony with nature.

The cowboy, like the Indian, has been idealized as a man of nature doomed to extinction by industrial progress. The costumes, equipment, and skills of the cowboy are represented with documentary accuracy, but he is, above all, a romantic hero. In the romance of the West, prospectors and pioneers, lawman and outlaw, all are devoted to and successful in the individual enterprise that characterized the spirit of the West. Very few Western paintings include women because the mythology of the West is a narrative of conquering and vanquished heroes. In Western paintings the stereotyped roles of men and women are clear, for the West represents the dreams and the cultural ideals of both artists and viewers.

Nineteenth-century Americans believed in the perfectibility of man. The settlement of the West represented the achievement of Manifest Destiny, and it was equated with the inevitable progress of mankind. The pioneer was the man of the future, and with him lay the potential for progress. The land of the West offered a chance for moral and spiritual regeneration, the opportunity for redemption and purification. Untamed nature, the land beyond the frontier of white civilization, was thought of as Eden. In the mythology of the West, however, this world of idyllic peace frequently was looked upon as a

barren wilderness, which must be tamed and given the gift of civilization.

Since the mid-nineteenth century, landscape painters have celebrated the rich, natural heritage of the West. Americans identified with their land and rejoiced in its beauty, which they took as evidence of divine grace. The land of the American West became not only a source of artistic inspiration, but also the focus of national pride. For over a century artists have painted the woodlands, mountains, deserts, and unique geological formations of the American West.

Paintings of the American West are images of an ideal world, pure and spiritually superior to the present. During the nineteenth century artists celebrated the West as the land of the future, America's promised land. Slowly, however, the pendulum swung, and by the twentieth century, artists extolled the West as the heroic land of the past.

In the twentieth century, influenced by the teachings and examples of Anglo-European civilization, Indian artists have documented the daily rituals and ceremonies of their culture. Heretofore, Indian art was an integral part of daily ceremonial life, and the artist was thought to contribute to the well-being of the society. Today Indian painters express their vision of Indian life and legend.

The artists who painted the American West were motivated by a sense of history. Their mission was to document the national heritage. These artists succeeded in their mission, for they not only recorded for posterity the events, people, and land of the American West, but through their work, they expressed the spiritual values, ideals, and beliefs of the American people. They achieved a success far beyond the creation of ethnological, historical, and geographical documents. Their paintings not only record the visual changes on the face of the American continent, but they testify to the changing ideals and beliefs of the American people. Paintings of the old American West are to be studied and valued as creative expressions of America's natural, cultural, and spiritual heritage. The West is uniquely American, and paintings of the American West are truly national treasures.

Patricia Janis Broder

Short Hills, New Jersey
January, 1979

GREAT PAINTINGS
OF THE
Old American West

Joshua Reynolds (1723–1792)

SYACUST UKAH, CHEROKEE CHIEF

DURING THE EIGHTEENTH CENTURY the British, French, and Spanish competed for the goodwill and favor of the Cherokee. In 1761 the British and the Cherokee signed a treaty of friendship. The Cherokee chiefs requested that the English send a representative to the Cherokee country in eastern Tennessee to convince them of their good intentions and sincerity. Lt. Henry Timberlake was chosen, and at the end of his six-month visit, he had won the confidence of the Cherokee chiefs. They exhibited their respect for him by insisting that they accompany him to Williamsburg. Chief Ostenaco then informed the English governor that he wanted to travel to England to "see the great king, my Father."

In 1762 three Cherokee chiefs—Kanagagota (Standing Turkey), Ostenaco (Judd's Friend), and Tohanohawighton (Pouting Pigeon)—escorted by Lt. Timberlake, were presented to King George III. Their interpreter had died aboard ship en route to England, and the lack of an interpreter led to great confusion during the course of the visit and made the interview with the king an empty formality. Timberlake recalled ". . . finding Ostenaco preparing his pipe to smoak with his Majesty, according to the Indian custom of declaring friendship, I told him he must either offer to shake hands or smoak with the king, as it was an honor for the greatest of our nation to kiss his hand."

Despite the problems of the visit, the British government viewed the trip as a success, for it believed the trip improved relations between the Cherokee and the British and that the tour instilled respect in the Cherokee for the might of the British Empire and for the king.

Joshua Reynolds completed the portrait of Chief Ostenaco. Reynolds was deaf and misunderstood Ostenaco's Cherokee name, Skiagusta Ustenacah, as Syacust Ukah.

Oil. 24¼ × 16½ in.

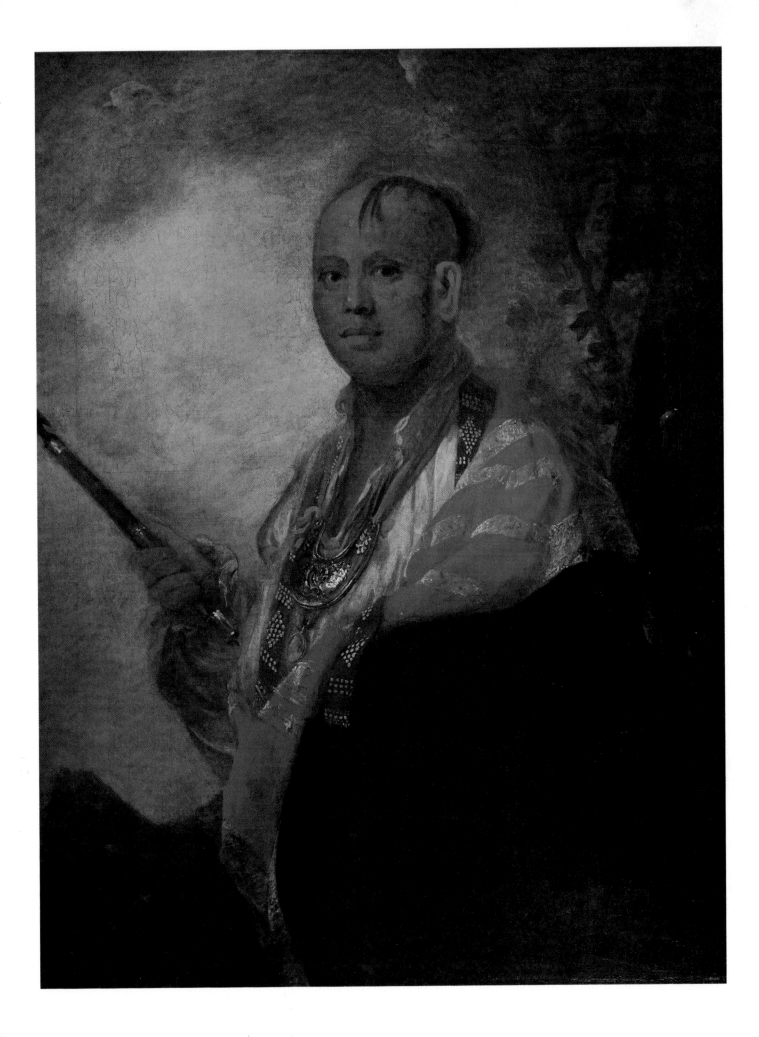

George Catlin (1796–1872)

SIOUX COUNCIL (1847)

GEORGE CATLIN WAS THE FIRST American artist to create a comprehensive record of the Indian tribes of the trans-Mississippi West. During the 1830s he traveled across the United States—from the Great Plains to the Rocky Mountains and from the shores of the upper Missouri to the Mexican border. He painted hunting scenes, religious rituals and ceremonies, and the everyday activities of the tribes he visited, as well as portraits of the Indian people. In addition to this vast pictorial record, consisting of drawings, watercolors, oil studies, and sketches, Catlin kept a detailed journal, which documented the culture of each tribe and frequently provided biographies of his portrait subjects. Catlin also gathered an extensive collection of Indian clothing, weapons, artifacts, and other ethnological material.

Catlin, following the cultural attitudes of his contemporaries, idealized the Indians as "noble savages." But in contrast to the mainstream of nineteenth-century thought, Catlin did not look upon the arrival of the white man as a heaven-sent opportunity for the Indian to enjoy the gift of civilization. Catlin had tremendous respect for the Indian people and for the integrity of Indian civilization. He recognized the tragedy of the inevitable destruction of these valuable cultures.

In 1832 Catlin arrived in the land of the Sioux and recorded the following in his journal: "This tribe is one of the most numerous in North America and one of the most war-like to be found. . . . Many of them have been supplied with guns, although the greater part hunt with bows and arrows and lances, killing their game from their horses while at full speed. . . . The great family of Sioux occupy a vast tract of country extending from the bank of the upper Mississippi River to the Rocky Mountains and are a migrating tribe, divided into forty-two bands of families, each having its own chief."

Oil. 25½ × 32 in.

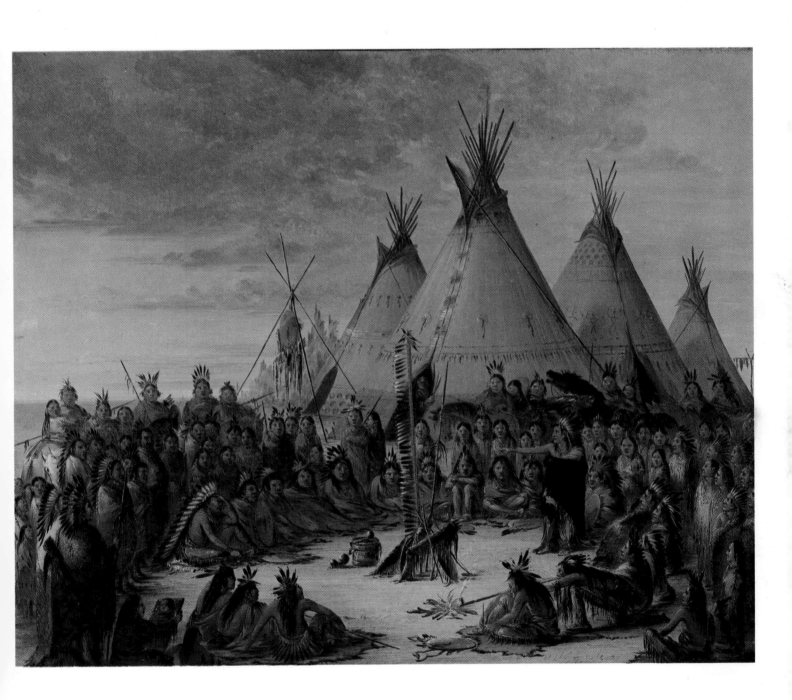

George Catlin (1796–1872)

CATCHING WILD HORSES

In 1834 GEORGE CATLIN, while accompanying the westward expedition of the first regiment of the Mounted Dragoons, had the opportunity to enter Comanche country. The leader of the Dragoons, Colonel Henry Dodge, with the aid of a Spanish interpreter, explained the peaceful purposes of the expedition and the Comanche offered to escort the visitors to their villages to meet their chiefs and to smoke the peace pipe. For several days the group traveled across Comanche land before arriving at the village, today known as Cache Creek, which is east of the Wichita Mountains.

The Comanche were a nomadic Plains people who subsisted primarily by hunting buffalo. In the sixteenth century the conquistadores first brought horses to the New World, and by the nineteenth century, herds of wild horses—descendants of those brought by the Spaniards—were a familiar sight in the Great Plains. The introduction of the horse to the Plains Indian culture greatly facilitated hunting and changed the methods of warfare. The Comanche were reputed to have the greatest skill in horsemanship. They were proud of their ability to capture and subdue the wildest horses and to perform feats of great daring.

In his journal Catlin described the Comanche method of capturing a wild horse: "When he starts for a wild horse, the Indian mounts one of the fleetest he can get, and coiling the *laso* on his arm, he starts off under 'full whip' till he can enter the band and throw the noose over the neck of one of the number. Then he instantly dismounts . . . and runs as fast as he can, letting the *laso* pass out gradually through his hands, by which their speed is checked and they are 'choked down' until the wild horse falls for want of breath and lies helpless on the ground When completely choked down, the Indian advances closely towards the horse's head, keeping his *laso* tight upon its neck, until he fastens a pair of hobbles on the animal's two forefeet. Then the *laso* is loosened, giving the horse a chance to breathe. He puts a noose around its underjaw, by which he gets great power over the affrightened animal, which begins rearing and plunging when it gets breath. As he advances, hand over hand . . . the horse makes every possible effort to escape, until its power is exhausted and it becomes covered with foam, and at last yields to the power of man. He gradually advances, until able to place his hand on the animal's nose and over its eyes; and at length to breathe into its nostrils, when it soon becomes docile; so he had little else to do than remove the hobbles, and lead or ride it into camp. . . ."

Oil. 24¼ × 16½ in.

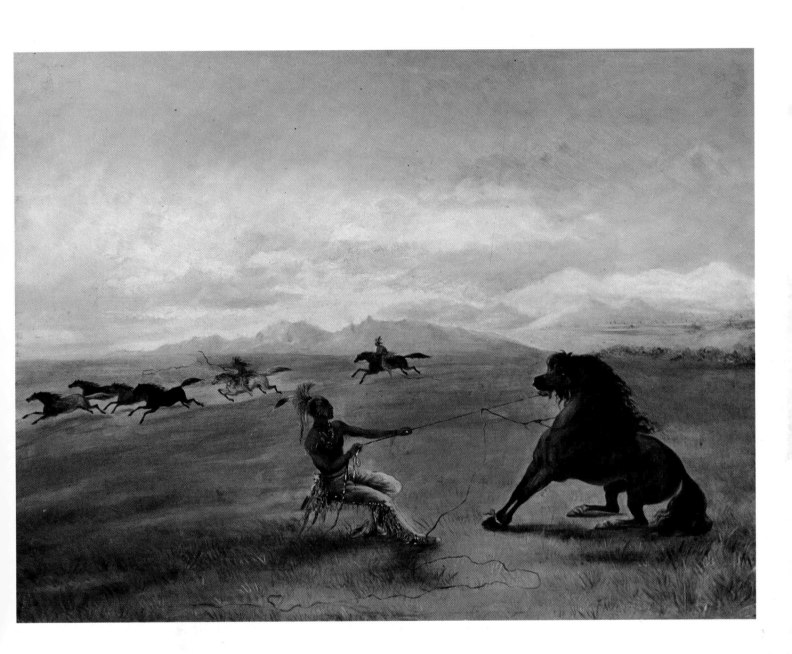

George Catlin (1796–1872)

GEORGE LOWREY

CHIEF GEORGE LOWREY PLAYED an important role in uniting the Cherokee people and healing the division which had developed following the United States government's removal of the Southeastern Indians to Indian Territory. Lowrey was one of the Old Settlers, or Western Cherokee, who were the earliest Cherokee to move into Indian Territory.

The Eastern Cherokee were bitterly divided between the followers of John Ross, who led the majority of Eastern Cherokee in their resistance to resettlement, and the followers of John Ridge, who believed it was useless to oppose government policy. For many years Ross had used his educational and cultural advantages to win property rights for the Cherokee. However, Andrew Jackson, President of the United States, led the opposition to Indian Rights, and in 1831 the Supreme Court denied the Cherokee property rights because they were "a domestic dependent nation." In 1835 Ridge signed the New Echota Treaty, which ceded to the United States government all Cherokee land. In return the Eastern Cherokee were given joint interest in land previously ceded to the Western Cherokee. Following the signing of the treaty, members of the Ridge party traveled to Indian Territory.

Although Ross and his followers protested the New Echota Treaty, in the fall of 1838 General Winfield Scott conducted about 13,000 Cherokee on a forced march to Indian Territory. About 4,000 Cherokee died along this part of the Trail of Tears.

Before leaving, the Ross party signed a resolution negating the New Echota Treaty and imposing a death penalty on any Cherokee who should propose the sale or exchange of Cherokee land. Following the arrival of the Ross party, the Cherokee were bitterly divided, and in 1839 John Ridge, his father, and another Ridge leader were assassinated. In July 1839 George Lowrey served as president of the convention at which the Cherokee met and adopted the Act of Union by which the Western and Eastern Cherokee were declared "one body politic, under the style and title of a Cherokee Nation." In 1846 Lowrey acted as principal chief in negotiating a treaty with the United States that secured the Cherokee land in Indian Territory.

In 1834 George Catlin accompanied an expedition of the First Regiment of Mounted Dragoons across the Southern Plains to the Rocky Mountains. Catlin visited the Western Cherokee in the vicinity of Fort Gibson and painted many of the leaders, including George Lowrey.

Oil. 26 × 22½ in.

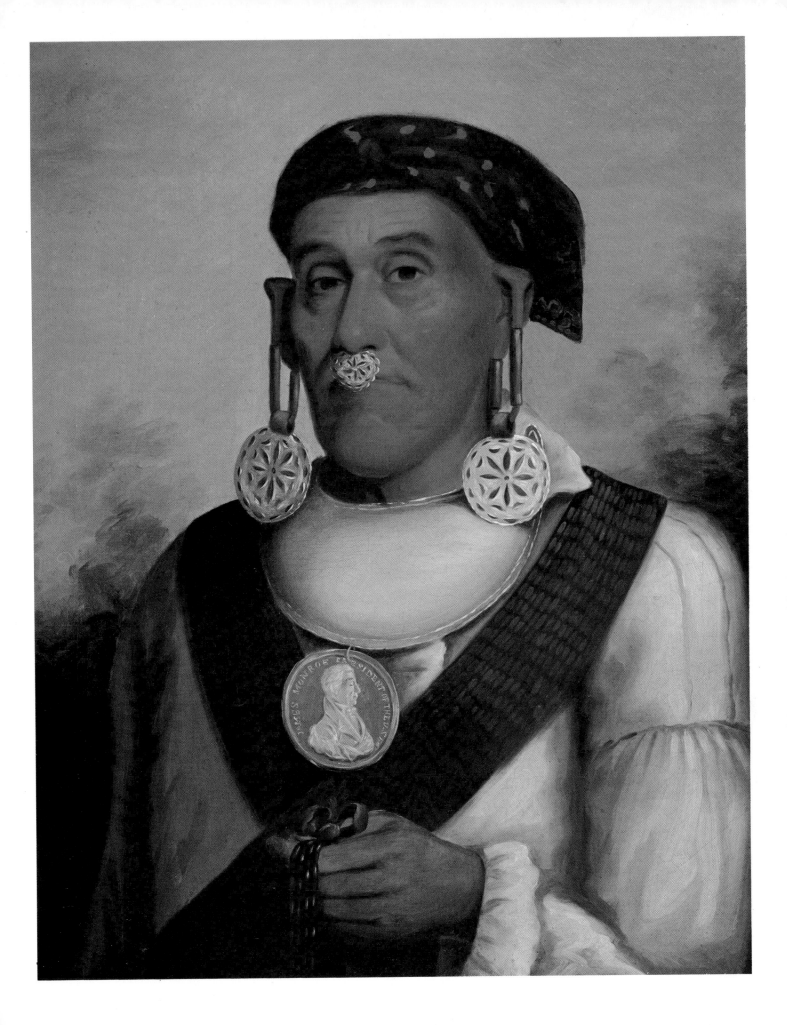

Karl Bodmer (1809–1893)

TRAVELERS MEETING WITH MINATAREES (1842)

I N 1833 ZURICH-BORN Karl Bodmer began a steamer voyage which followed the historic route of Lewis and Clark beyond the established western frontier to the source of the Missouri River. Bodmer traveled aboard the Yellowstone, the same American Fur Company steamer that George Catlin had traveled on the year before. Bodmer sketched many of the same scenic views, Indian people, and ceremonies as Catlin. Bodmer, in contrast to Catlin, was not a solitary traveler on a personal artistic mission but was the official artist hired by the German prince, Maximilian of Weid Neuwied, to accompany him on a tour of the United States. Maximilian's goal was to reach the Rocky Mountains and study the inhabitants of the American West.

During the first half of the nineteenth century, the Missouri River was the principal route for travelers beyond the western frontier. Maximilian's objective was to provide a written and visual record of the Indians of the Upper Missouri, as well as a report on the geology, geography, climate, and animal and plant life of the area. In 1843 Maximilian published *Travels in the Interior of North America*. It was supplemented the following year with a folio of polychrome engravings, which were based on the work of Karl Bodmer. Today this folio is considered to be the most comprehensive and highest quality pictorial record of the Missouri frontier ever published.

Bodmer, a carefully trained artist and observer, recorded with anatomical precision the physical structure and facial likenesses of the tribes along Maximilian's route. He also recorded the costumes and artifacts of the Indian people. On the return trip Maximilian visited Fort Clark again to study the Mandan and Minataree.

The Minataree, best known as the Hidatsa, were a farming tribe who lived in villages of earth lodges along the banks of the Missouri in the territory that is now the state of North Dakota. The Minataree spoke a Sioux tongue, and they were bordered by the Mandan on the north and the Arikara to the south. In 1837 an epidemic of smallpox swept across the plains and destroyed both the Mandan and the Minataree civilizations. Today only remnants of these tribes remain in Montana.

Travelers Meeting with Minatarees documents a meeting in 1834 of the Maximilian party and the Minataree. The meeting took place at Fort Clark, a fortified post similar to those built along the trade route of the Missouri. Bodmer painted Maximilian standing in a Napoleonic pose, his hand inside his coat. Bodmer is in the painting, standing at Maximilian's side.

Lithograph. 11 × 13½ in.

fig. XIII.

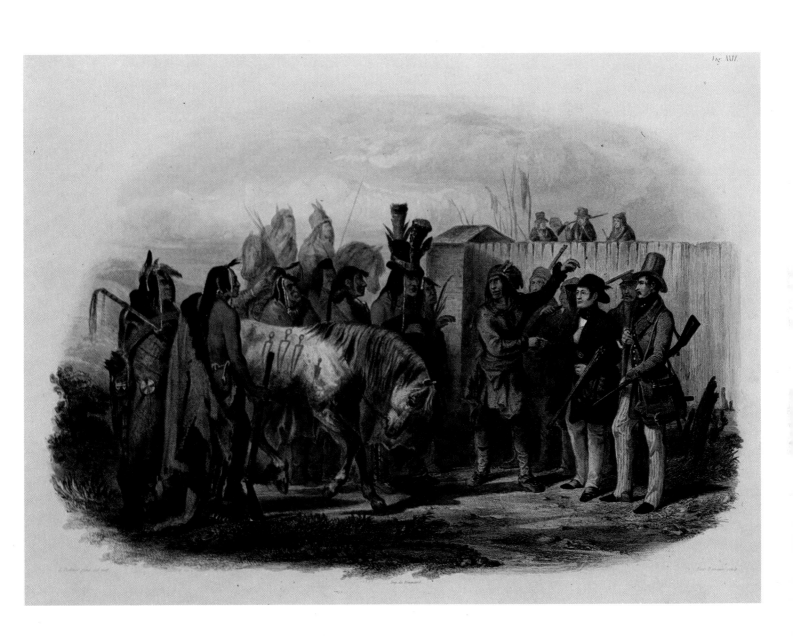

Alfred Jacob Miller (1810–1874)

SIR WILLIAM DRUMMOND STEWART
MEETING INDIAN CHIEF

CAPTAIN WILLIAM DRUMMOND STEWART, a nobleman from Scotland with a taste for hunting, travel, and adventure, was responsible for one of the finest pictorial records of the Far West, and of the life and land of the Indians of the Great Plains and Rocky Mountains before the western migration of Anglo-Europeans. In the 1830s the only white men in the Rocky Mountains were trappers and traders, and the Indians lived as they had for centuries in a land untouched by the civilization of the white man. Stewart, who had served in the British army for twelve years and had fought at Waterloo, had first traveled to the American West in 1833 when he had accompanied a caravan of the Rocky Mountain Fur Company to the Green River trappers' rendezvous. Fascinated by the Indians, trappers and traders, and the scenery of the West, Stewart returned each summer for the next six years.

In 1837 Captain Stewart entered the New Orleans studio of Alfred Jacob Miller—a Baltimore-born, Paris-trained portrait and landscape painter— and asked the twenty-six-year-old artist to accompany him on an excursion to the Rocky Mountains "to sketch the remarkable scenery and incidents of the journey." That spring Stewart, with a party of ten men and two covered wagons, joined a caravan of American Fur Company traders under the direction of Tom Fitzpatrick for the journey across the Great Plains to the Green River rendezvous. Fitzpatrick, impressed with Captain Stewart's military background and experience in traveling among the Indians of the Plains and Rockies, gave him authority over the fur company men for the duration of the expedition. The caravan set out from Independence, Missouri, followed the North Platte River to Fort Laramie, then traveled up the Sweetwater River across South Pass into the Green River Valley. Miller sketched the events of each day, the men and women of the tribes, and the scenery of each area.

Following the summer in the West, Miller returned to New Orleans to paint finished pictures of the expedition for Stewart's family castle. In 1838 Stewart again traveled to the West, but his brother's death forced him to return to Scotland to head the noble family. In 1840 Miller traveled to Scotland and remained at Murthly castle for over a year, painting scenes of his adventures with Stewart.

In *Sir William Drummond Stewart Meeting Indian Chief,* Captain Stewart sits on a white horse. In the West the firing of a rifle or musket into the air was a signal of friendship.

Oil. 33 × 42 in.

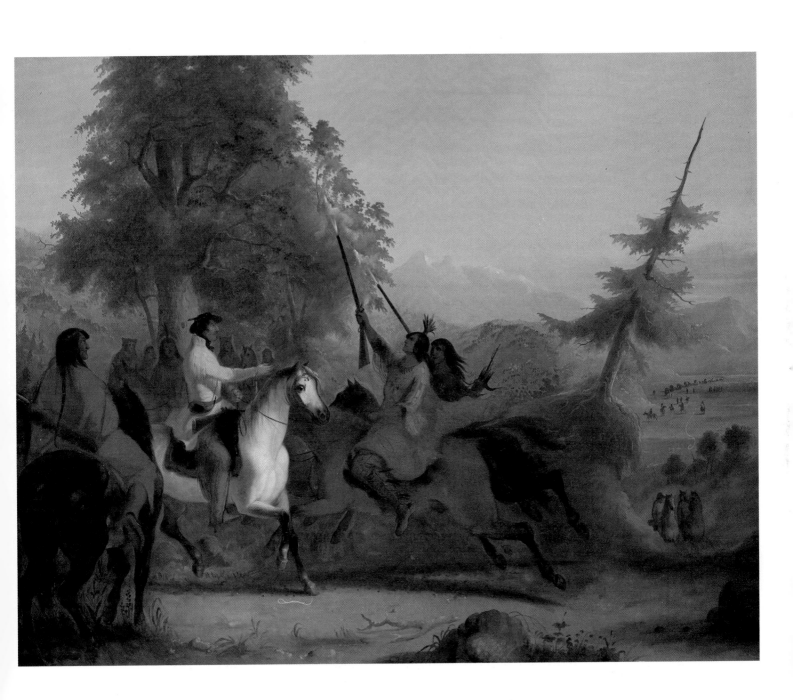

Alfred Jacob Miller (1810–1874)

FORT WILLIAM

F ORT WILLIAM WAS BUILT on the banks of the Laramie River in Upper Missouri country. The fort was built by William Sublette and Robert Campbell of the Rocky Mountain Fur Company. Almost immediately after its construction, the Rocky Mountain Fur Company was dissolved and ownership was transferred to the American Fur Company. Fort William was used as a trading center from 1834 until 1840 or 1841. Then another fort was built, and Fort William fell into disuse. The new fort, made from adobe rather than plank, was called Fort Laramie, and it was situated a short distance downstream from Fort William.

Surrounded by palisades of 16-foot-high split timbers, Fort William could be seen for miles in this almost treeless land. Captain Stewart's party stopped for a few days at Fort William, and Miller made numerous sketches of both the interior and exterior.

Miller wrote of Fort William: "The post was built by the American Fur Company situated about 800 miles West of St. Louis, is of a quadrangular form, with bastions at the diagonal corners to sweep the fronts in case of attack; over the ground entrance is a large block house, or tower, in which is placed a cannon. The interior is possibly 150 feet square, a range of houses built against the palisades entirely surround it, each apartment having a door and window overlooking the interior court. Tribes of Indians encamp here 3 or 4 times a year, bringing with them peltries to be traded or exchanged for dry-goods, tobacco, vermillion, brass, and diluted alcohol. . . . The Indians have a mortal horror of the big gun which rests in the block house as they have experienced its prowess. I witnessed the havoc produced by its loud talk. They conceive it to be only asleep and have a wholesome dread of its being waked up.

". . . When this space is filled with Indians and Traders as it is at slated periods, the scene is lively and interesting. They gather here from all quarters. From the Gila at the South, the Red River at the North, and the Columbia River West, each has its quota and representatives. Siouxs, Bannocks, Mandans, Crows, Snakes, Pend-Oreilles, Nez Perces, Cheyennes, and Delawares—all except the Blackfeet, who are *bête noirs* and considered *de trop*. As a contrast, there are Canadian Trappers, free and otherwise, Halfbreeds, Kentuckians, Missourians, and Down Easters. A Saturnalia is held the first day and some excess is committed. But after this trading goes briskly forward."

Oil. 18 × 27 in.

24

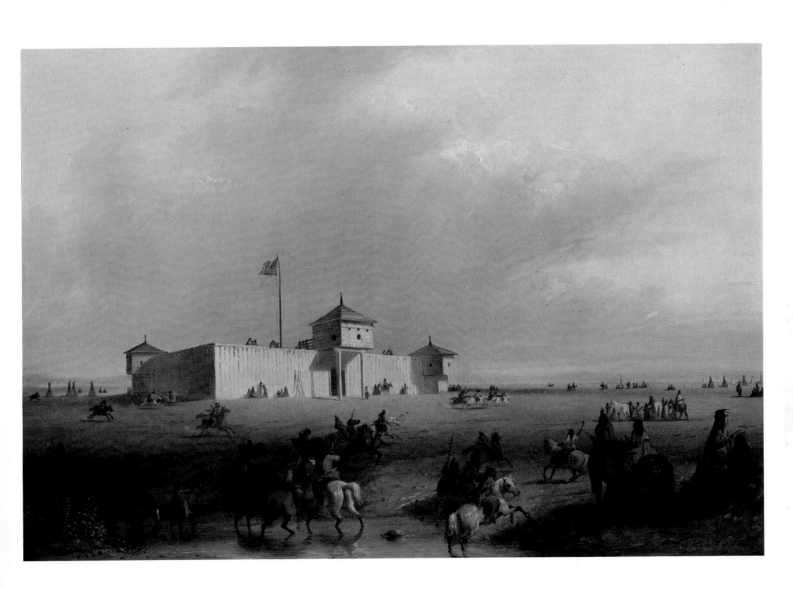

Alfred Jacob Miller (1810–1874)

SNAKE AND SIOUX INDIANS
ON THE WARPATH

In the course of their expedition across the Great Plains to the Rocky Mountains, Stewart's party had observed the lives and customs of many Indian tribes. Miller, in *Rough Draft of Notes on Indian Sketches,* recalled his impressions of the Sioux, and the Snake, or Shoshone, Indians:

"The Sioux, or Dacotahs, and the Snake Indians were the finest Indians decidedly that we met with—they seemed to be better dressed, had more horses, and were more cleanly in their habits than others, are very warlike, and almost continually engaged in battle.

"On the top of the head they wear a tuft of hair terminating in a long que, ornamented with flat plates and rings made of brass, from the size of a dollar to that of a dime. The tuft of hair, we were told, was not only left for an ornament, but in case of defeat, that their enemy might secure their scalp. A wise forethought, certainly exhibiting a noble trait of character, and a most liberal provision for those that valued the article.

"In looking at a body of these savage fellows scouring the prairies, one cannot fail to be impressed with their admirable horsemanship. . . . A piece of Buffalo robe serves for a seat and their bridle is simply composed of a piece of rope made of plaited bull-hide, attached to the lower lip of the horse—this is all they require. Their great hold on the horse is with their knees and it is almost impossible for an animal to throw them.

"Their usual arms are a lance about 8 or 9 feet long tipped with an iron spear, bow and quiver of arrows, tomahawk and sometimes a shield covered with tough bull hide painted with figures and ornamented with eagle feathers and scalps. The indispensable scalping knife in a highly ornamented scabbard is either suspended from the neck, or worn in the belt.

"When a tribe has a grievance either through loss of any of their men or depredations committed against them, the chiefs summon their young warriors, arm, dress, and paint themselves elaborately and set out on the warpath."

Miller's paintings are romantic rather than scientific. Miller did not document the ethnological and geological details of each area he visited, but he did capture the mood and spirit of the Indians and the atmospheric beauty of the mountains and the plains.

Oil. 29 × 36 in.

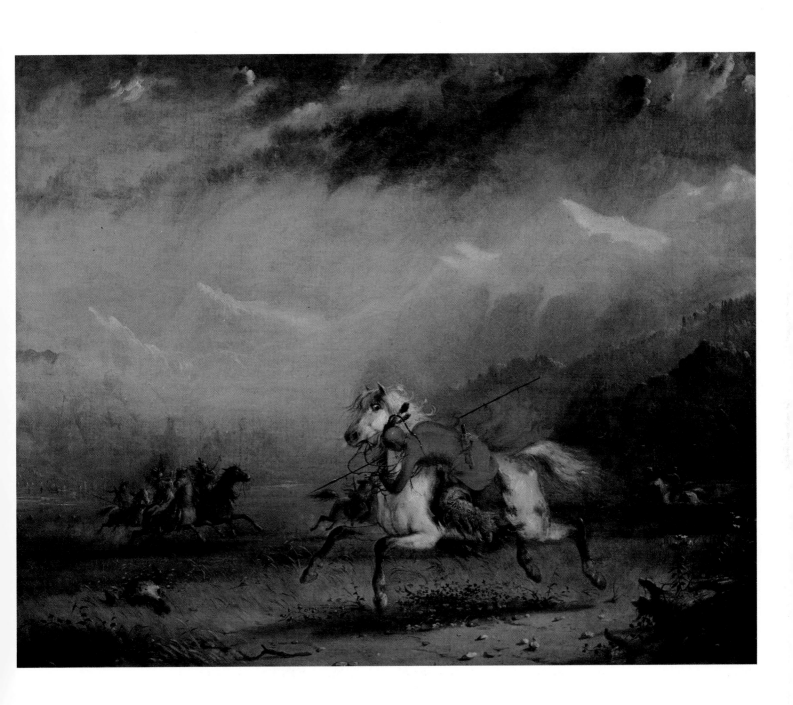

Seth Eastman (1808–1875)

THE INDIAN COUNCIL

AN EXCELLENT DRAFTSMAN and competent painter, Seth Eastman was devoted to documenting the life and land of the Indian inhabitants of the American continent. He was a realist, more interested in the accuracy of his representation than in the expression of sentiment or romanticism.

Seth Eastman combined two careers—military officer and artist. A graduate of West Point and an officer in the United States Army, he engaged in active combat against the Indians in Florida, in the region of the Upper Mississippi, and in Texas. In the course of his military service, he completed documentary records of military forts and Indian villages and landscapes of the Upper Mississippi. Trained in topographical drawing and an objective observer of the Indian people and Indian life, during his lifetime Eastman won recognition for his comprehensive pictorial records of the American Indian. He illustrated a six-volume work commissioned by the Bureau of Indian Affairs, written by Henry R. Schoolcraft, entitled *Indian Tribes of the United States.*

From 1830 to 1833 and from 1841 to 1848, Eastman was stationed at Fort Snelling, the principal military stronghold and supply base in the Northwest. Located seven miles below the Falls of St. Anthony, this area is now the city of Minneapolis. At Fort Snelling, Eastman lived among the Sioux, with the Chippewa as his northern neighbors.

On his second assignment to Fort Snelling, Eastman was accompanied by his wife, Mary Henderson Eastman, and their children. The Eastmans collaborated on several successful books on Indian life in the West. Their first book, *Dakotah, Life and Legends of the Sioux,* was the inspiration for the poem *Hiawatha.* In 1849 Eastman was ordered to Washington, where he devoted his full attention to completing a series of oil paintings based on his frontier sketches. *The Indian Council* was completed in Washington during this period.

Oil. 26 × 35 in.

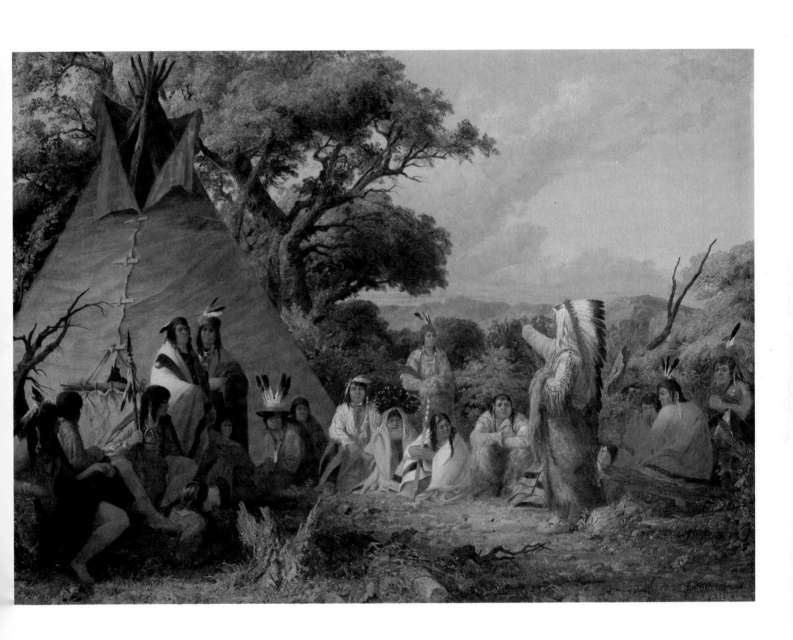

John Mix Stanley (1814–1872)

GAME OF CHANCE

In 1852, 152 PAINTINGS by John Mix Stanley were exhibited at the Smithsonian Institution in Washington, D.C. In the preface to the catalogue, Stanley described the exhibition as: "accurate portraits painted from life of forty-three different tribes of Indians obtained at the cost, hazard and inconvenience of a ten-year tour through the Southwest provinces, New Mexico, California and Oregon." The exhibition represented the first step in the fulfillment of his life's ambitions and the achievement of his artistic mission. Stanley's ultimate goal was for Congress to purchase his collection of paintings for permanent display in the Smithsonian Institution.

Following the exhibition, Congress agreed to temporarily house Stanley's work, although no commitment of purchase was made. He had begun negotiations with the government before the exhibition and had continued to fight congressional delay until 1865, when a fire consumed the section of the Smithsonian containing his paintings. Only five paintings, which had been moved to another part of the building, were saved. Following the disaster, Stanley went to Germany to have the remaining five paintings reproduced by chromolithograph. Such reproductions would give permanence to his work and provide financial support when sold. His lifework destroyed, Stanley received from Congress, as compensation for his loss, permission to import, duty-free, twenty-thousand of the chromolithographs. When Stanley died seven years after the fire, he had completed his mission. However, only a fraction of his life's work had survived as testimony to his commitment and achievement.

John Mix Stanley was born and raised in the Finger Lakes region of New York State. The son of a local tavern keeper, at fourteen he was apprenticed to a coach maker, from whom he learned decorative painting. He later worked as a sign and house painter and became a partner in a portrait studio in Chicago. As a boy he enjoyed drawing pictures of the local Seneca Indians. In 1839 he traveled to Fort Snelling, Minnesota, where he completed his first mature paintings of Indians, which included both portraits and scenes of daily life. In *Game of Chance*, Stanley painted a group of Siouxlike Indians, similar to those he saw enjoying a moment of relaxation near Fort Snelling.

Oil. 28¼ × 39⅜ in.

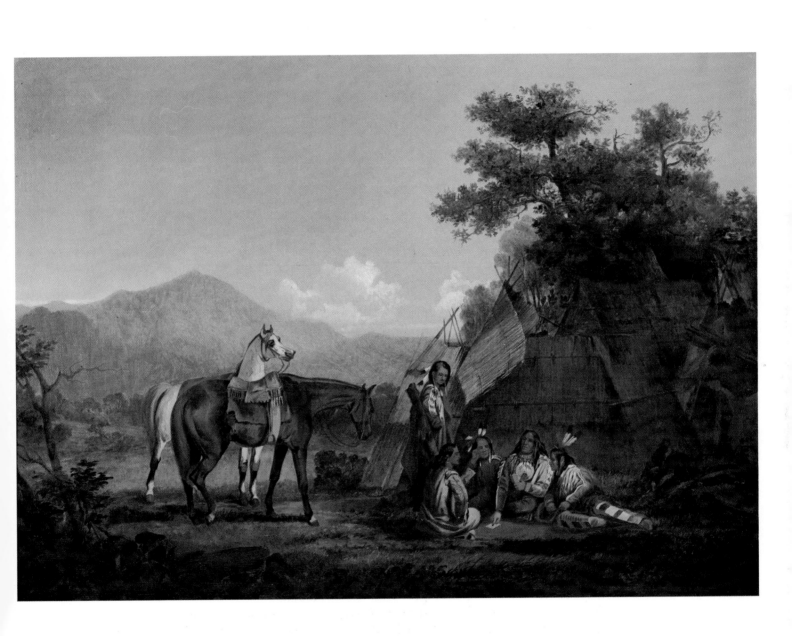

John Mix Stanley (1814–1872)

SCOUTS IN THE TETONS

WITH THE EXCEPTION OF GEORGE CATLIN, John Mix Stanley covered more territory in the trans-Mississippi West and visited more Indian tribes than any other American artist. From 1839 until 1853 John Mix Stanley traveled the major overland routes and witnessed several epochs in the history of the American West. In 1842 Stanley traveled to Arkansas Territory and visited Fort Gibson. In 1843 he attended an Indian conference at Tehlequah, capital of the Cherokee Nation. At this conference eighteen tribes met to "preserve the existence of our race" by discussing problems created by the United States government's removal of the Indian tribes of the Southeast to Indian Territory (Oklahoma).

In 1846 Stanley joined the Magoffin Expedition, which traveled along the Santa Fe Trail to New Mexico Territory. It was led by the trader Josiah Gregg. In Santa Fe, Stanley enlisted as topographical draftsman for Major Stephen Kearny's expedition to San Diego. W. H. Emory commanded the advance guard and Kit Carson served as guide across the desert and mountains. In California, Stanley fought against the Mexicans in the war that resulted in the annexation of California to the United States. In 1847 Stanley traveled overland to Fort Walla Walla in Oregon Territory and faced the dangers of Indian hostility in the days just after the massacre of Dr. Marcus Whitman, his wife Narcissa, and ten pioneers. During Stanley's stay in the Northwest, he traveled a thousand miles by canoe down the Columbia River. From Oregon, Stanley went to Honolulu where in 1848 he painted the portrait of King Kamehameha III. In 1853 Stanley traveled as the official artist on an expedition that surveyed for a possible railroad route from Minnesota to Puget Sound. The party, under the command of Isaac I. Stevens, governor of the Washington Territory, traveled across the Northern Plains and the Rocky Mountains.

In *Scouts in the Tetons*, Stanley has painted a romantic portrait of Americans who shared his love of travel and adventure. The scouts look out in four directions on the bright horizon of the American West. Silhouetted against the sky, they stand firm on a foundation of rock. In the nineteenth century, scouts, like expeditionary painters, were both the romantics and realists of the American West.

Oil. 24 × 34⅛ in.

32

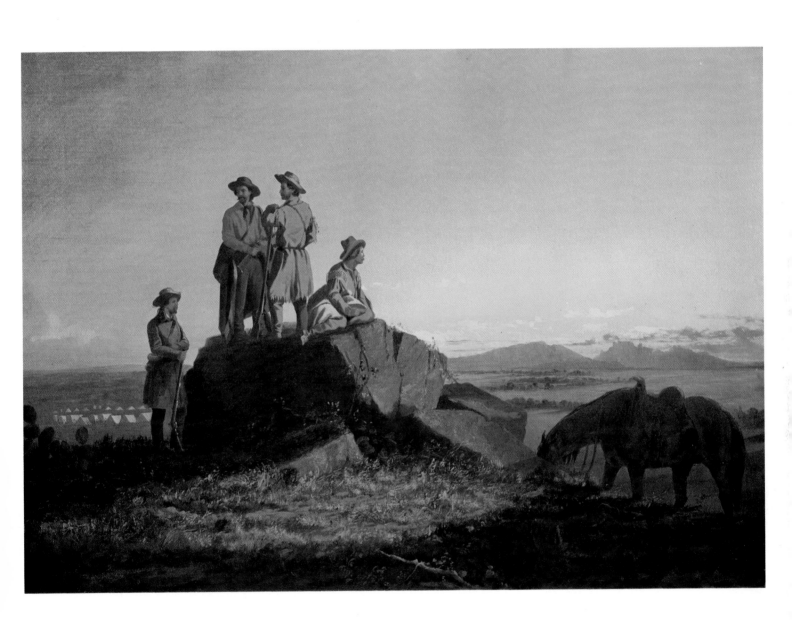

Charles Deas (1818–1867)

INDIAN BALL GAME (1843)

In 1839 CHARLES DEAS visited the George Catlin Indian Gallery Exhibition and recognized the importance of the Catlin paintings. Determined to follow Catlin's example, he passionately urged Congress to buy this unique documentation of America's national heritage. In 1840 Deas left Philadelphia to work and travel in the West. He first traveled to Ft. Crawford (Prairie du Chien) where his brother, an officer in the Fifth Infantry, was stationed. Deas had the opportunity to accompany both the military and the American Fur Company parties on missions to the surrounding forts and into Indian Territory. In 1841 he established a permanent residence and studio in St. Louis but continued to spend several months each year among the Indians. In 1844 Deas accompanied Major Wharton's military expedition through the Pawnee villages on the Upper Platte River. According to the chronicler of the expedition, Lt. J. Henry Carlton, Deas was nicknamed "Rocky Mountain," for he dressed and acted like a Rocky Mountain fur trader and hunter.

Although the majority of Deas' work emphasizes the perils and melodrama of life on the frontier, *Indian Ball Game* depicts one of the pastimes in the everday life of the Indian people. Deas' love of the theatrical prevailed, however, for he chose a moment of physical conflict, and he portrayed the Indians as stereotyped, primitive muscle men. His melodramatic paintings of the terror and violence of life on the frontier won high praise in the mid-nineteenth century. Today, however, the majority of his works have been lost, and Charles Deas has been virtually forgotten.

Deas worked in the West for only seven years, for he was troubled by acute melancholia and in 1847 suffered a severe mental breakdown. After many years of confinement, Deas died in an asylum.

This ball game is the oldest organized sport played in North America. The French and English watched the Indians at play, and in 1840 the French settlers revived the rules and adopted the game. They named the game Lacrosse because of the long-handled hook stick, which resembles the Bishop's staff, or *crossier*.

Oil. 29 × 37 in.

34

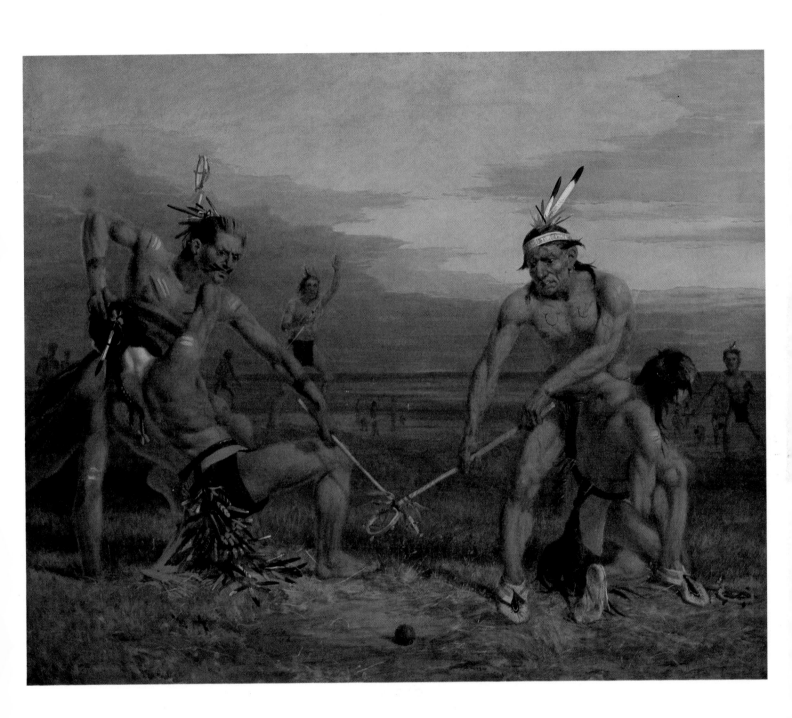

Carl Wimar (1828–1862)

BUFFALO HUNT (1861)

CARL WIMAR'S ARTISTIC GOAL was to create a pictorial record of the Indians, the native people of America, just as John James Audubon had documented the native animal and plant life of the continent. Wimar followed the traditions of romantic realism expounded by the Düsseldorf School in which he had been trained.

Born in Siegburg, Germany, Wimar lived in St. Louis during the 1840s, the years when St. Louis was the focal point of the fur trade. During his youth Wimar had the opportunity to see Indian encampments and make friends with the Indians who traveled to St. Louis to trade. By the 1850s the fur companies established trading posts along the Missouri River, and the rich panorama of Indian life in St. Louis belonged to the past.

Wimar had his first opportunity to witness Indian life beyond the frontier of white settlement in 1849 when he accompanied his first art teacher on a journey by steamboat to the Falls of St. Anthony to make sketches for a panorama of the Mississippi River. During the 1850s Wimar took at least three river trips on boats belonging to the American Fur Company. The six-month trip from St. Louis to the headwaters of the Missouri covered over 2,500 miles and cost $150. During the course of these trips, Wimar sketched, painted oil and watercolor studies, and used a camera to document the Indian world. Wimar's daguerreotypes are some of the earliest photographs of western Indian life.

During one trip Wimar made a side journey up the Yellowstone, where he had the opportunity to witness the vast herds of buffalo that inhabited the region. Wimar described the view: "Herds of buffalo frequently swam the river in front of our boats, crossing so often that many times we entertained great fears for our safety. We killed, often, many of these animals and generally selected for food the female, leaving the others to the wolves, who followed our track in great numbers and prevented many times our sleep by their prolonged and monotonous howlings."

Wimar gained firsthand knowledge of a culture in which buffalo meat provided food, and buffalo skins clothing and shelter. Buffalo bones were the tools of the people. The sinews of the buffalo were used as thread, and buffalo dung—known as buffalo chips—was burned as fuel. To the Indian the buffalo was a gift from the Great Spirit. It was to be used with care and with a concern for conservation.

Oil. 22 × 33 in.

36

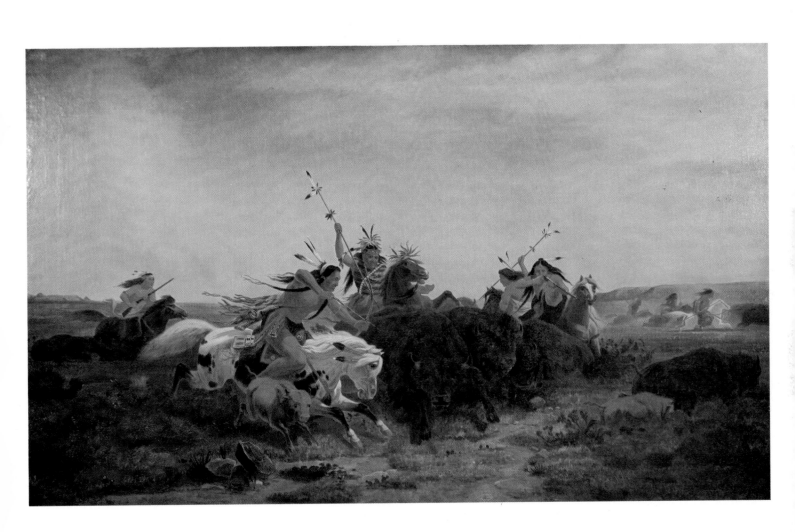

Cornelius Krieghoff (1815–1872)

WINTER DUTIES (1860)

Cornelius Krieghoff is an outstanding Canadian artist who painted pioneer and Indian life on the frontier. Before emigrating to the United States, Krieghoff worked as an itinerant musician and as a portrait and genre painter. While serving with the American army during the Seminole war, Krieghoff became interested in Indian life. Following the war he married a French Canadian and moved to Canada. Krieghoff painted Indian and frontier life both in the United States and in Canada and was the first genre painter of major importance in Canada.

Oil. 13 × 21 in.

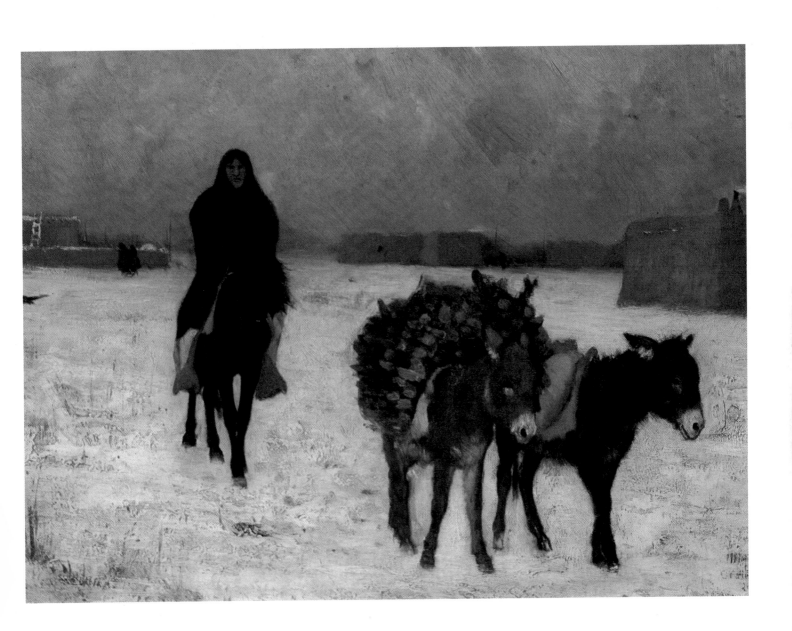

Charles Bird King (1785–1862)

WHITE CLOUD (1825)

DURING THE NINETEENTH CENTURY, it was the policy of the federal government to invite Indian leaders to visit Washington and tour some of the major American cities. The purpose of these trips was to impress the Indians with the size of the population of the white nation and the wealth of the cities and instill in the Indian a respect for America's power and wealth. The most successful of these official visits occurred in the 1820s, the decade before the government decided to move the principal eastern tribes to western reserves.

In 1821 Upper Missouri Agent Benjamin O'Fallon sent a delegation of fifteen Pawnee, Omaha, Oto, Kansa, and Missouri Indians to Washington. The Indians were lodged in the best accommodations of the Indian Queen Hotel. They were also provided with elaborate meals, whiskey, and new clothing, which included full military uniforms. The high point of the visit was a meeting with the Great White Father, the president of the United States.

Thomas L. McKenney, Superintendent of Indian Affairs (often referred to as Kickapoo Ambassador because of his sympathy for the Indians) conceived the idea of an Indian Portrait Gallery as part of the American Indian Archives in his office. The Indian Archives was planned as a permanent record of a race of aborigines who were destined to be destroyed by the inevitable march of progress.

Portraits of Indian leaders were a progressive idea in the early nineteenth century because the selection of a specific Indian as a portrait subject recognized the dignity of the Indian as an individual—a human being with an identity of his own rather than an example of a noble savage.

McKenney commissioned Charles Bird King to paint the majority of the portraits. By 1842 King had painted at least 143 portraits for the Government, at a cost of about $3,500. McKenney was severely criticized for squandering such an outrageous sum of government funds "for the pictures of these wretches the use of which it would be impossible to tell."

King painted the portrait of White Cloud or Mak-hos-kah, Chief of the Gowya—an Iowa tribe—in 1825. In the same year White Cloud visited Washington as a guest of the United States government, and the Iowa ceded all their land in Missouri to the United States.

Oil. 17 × 14 in.

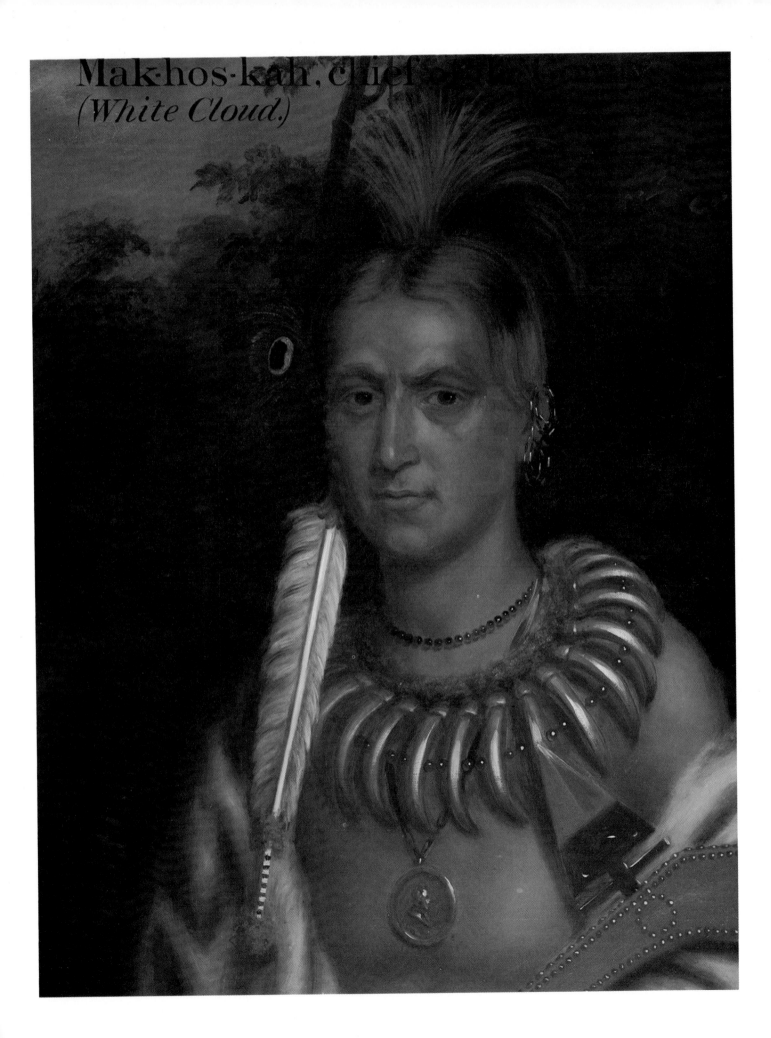

Mak-hos-kah, chief
(White Cloud.)

John Wesley Jarvis (1780–1840)

BLACK HAWK AND HIS SON, WHIRLING THUNDER (1833)

In 1833 FOLLOWING THEIR DEFEAT by the United States Army, Black Hawk, a Sac war chief, his son, Whirling Thunder, and several warriors were summoned to Washington by President Andrew Jackson. The Sac and Fox were two small tribes living in villages along the Missouri River in the area of Iowa and Illinois. Black Hawk had led his people in one last stand against the encroachment of white settlers on their hereditary land, but the Black Hawk War ended with their defeat in 1832 at the Battle of Bad Axe.

Jackson's intention in bringing Black Hawk and the other warriors to Washington was to impress the captives with the accomplishments and overwhelming numbers of the white man. This was done so the Indians would never again attempt to fight against the United States. When interviewed in Washington, Black Hawk said: "We did not expect to conquer the whites. They had too many houses and too many men. I took up the hatchet, for my part, to revenge the injuries which my people could no longer endure."

Jackson then arranged for Black Hawk to tour the United States, a tour which was intended to be a source of punishment and humiliation to Black Hawk and to coincide with his own political campaign. Jackson had made an error in judgment, however, and the tour was transformed into a triumph for Black Hawk. The people were greatly impressed by Black Hawk, who projected great dignity, nobility, and wisdom. The Indians were lavishly entertained and surrounded by crowds in each city they visited, and Jackson, overshadowed by his captive, cut the tour short when they reached New York and sent the Indians home. Black Hawk said of his career, "The path to glory is rough and many gloomy hours obscure it." On meeting President Jackson, Black Hawk looked silently at his captor and said, "I am a man and you are another."

While the tour was in New York City, Black Hawk and Whirling Thunder posed for the English portrait artist John Wesley Jarvis. Jarvis's most important work was a series of full-length portraits of military and naval heroes for the city of New York.

Oil. 23½ × 30 in.

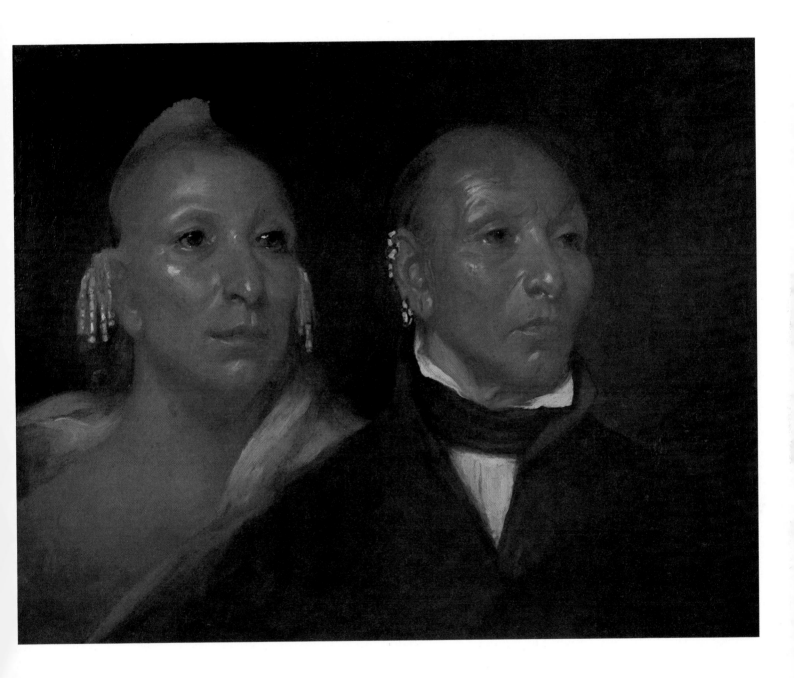

Jules Tavernier (1844–1889)

INDIAN CAMP AT DAWN

INDIAN CAMP AT DAWN is part of the pictorial record of the western travels of Jules Tavernier. Tavernier, a young Frenchman, arrived in the United States in 1871 and went to work as an illustrator for *Harper's Weekly.* In 1873, accompanied by Paul Frenzeny, a fellow artist, he traveled across the continent on a sketching tour, then completed a series of drawings and paintings which were published as illustrations in *Harper's.* Very few of the original oils, however, have been located. Tavernier remained in California where his work won popular and critical approval; however, dependence on alcohol destroyed his career. Deep in debt and pursued by creditors, Tavernier once again moved farther west, across the Pacific to Hawaii, where he died of alcoholism.

Indian Camp at Dawn is in the tradition of American luminist painting. A luminist painter has the dual role of reporter and poet, and his creation is a fusion of the real and the ideal. In a luminist work, nature is painted as a smooth mirrorlike surface, which hardly shows a trace of the artist's hand. Peace and tranquillity prevail; time has stopped and all is bathed in an eternal spiritual light. In Tavernier's work the viewer is aware that the artist has visited the Indian world and has reported this experience with accuracy. The teepees and the Indians are painted with precision and objectivity and have a solidity and tangible reality.

Throughout the nineteenth century, the romanticized view of Indian life as an idyllic existence of nature's noblemen existed concurrently with the view of the Indian as a savage and foe. In *Indian Camp at Dawn*, the viewer experiences the ordered serenity of Indian life, a life where pure people live in harmony with each other and with nature. The wide open spaces evoke a sense of the eternal. Dark clouds have gathered overhead—perhaps an omen that this ideal world will soon vanish forever—but on the horizon the light is clear and bright.

Oil. 24 × 34 in.

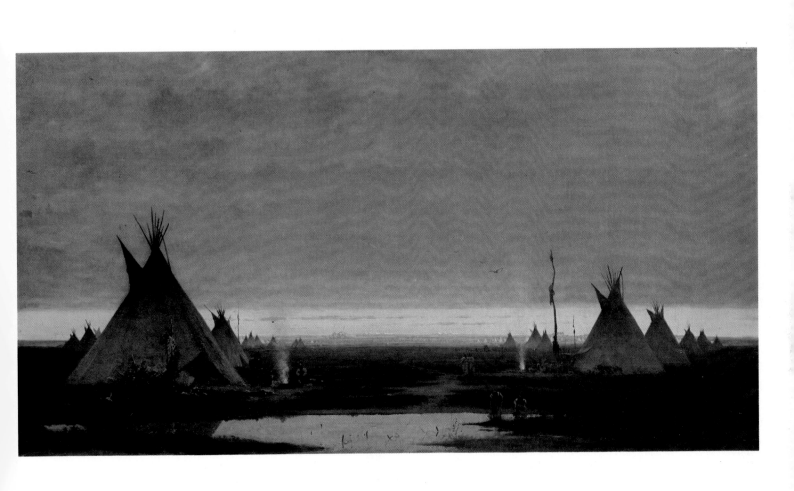

William Ranney (1813–1857)

DANIEL BOONE'S FIRST VIEW OF THE KENTUCKY VALLEY

DURING THE NINETEENTH CENTURY there was widespread interest in the pioneers who had opened the way to the West. Daniel Boone, the leader of the first settlers across the Cumberland Gap, was a folk hero celebrated in stories, paintings, and poetry. William Ranney, like many of his contemporaries, was fascinated by the history and legends of Boone and completed several paintings of him.

Young Daniel Boone first crossed the Cumberland Gap with five companions and lived in the wilderness of Kentucky for two years. In 1775 Colonel Richard Henderson, a Carolina judge, arranged for Boone to meet with twelve hundred Cherokee. Boone acquired almost two million acres of land from the Cherokee in return for a few wagon loads of guns, trinkets, and gaudy shirts. Henderson then hired Boone and a crew of thirty workers to cut a three-hundred-mile trail through the wilderness to Kentucky which became known as the Wilderness Road. At the end of the road, they built log cabins and started a fort, the beginning of the community of Boonesboro. Constant conflict with the Indians characterized the early years of Boonesboro, and Boone led the pioneers in defending their homes. Nineteenth-century patriots hailed Boone's settlement of Kentucky as the first major step toward achieving America's Manifest Destiny. Ranney painted Boone's first view of the wilderness that was to become the Kentucky Territory.

Nineteenth-century romanticism equated a view of the wilderness with a vision of paradise. The settlers looked on the land as a virgin wilderness to which they would bring the gift of civilization. In Ranney's painting, Boone stands contemplating the sublimity of the world in its Edenlike state before civilization.

In 1832 Ranney, the son of a Connecticut sea captain, enlisted in the Texas Cause. This was his first opportunity to come into contact with the people and the land of the American West. From 1837 until his death, Ranney lived in the East, where he painted portraits, sporting scenes, and dramatic canvasses of the West, which were inspired by his memories of trappers and traders, settlers, frontiersmen, and Indians.

Oil. 36 × 52½ in.

46

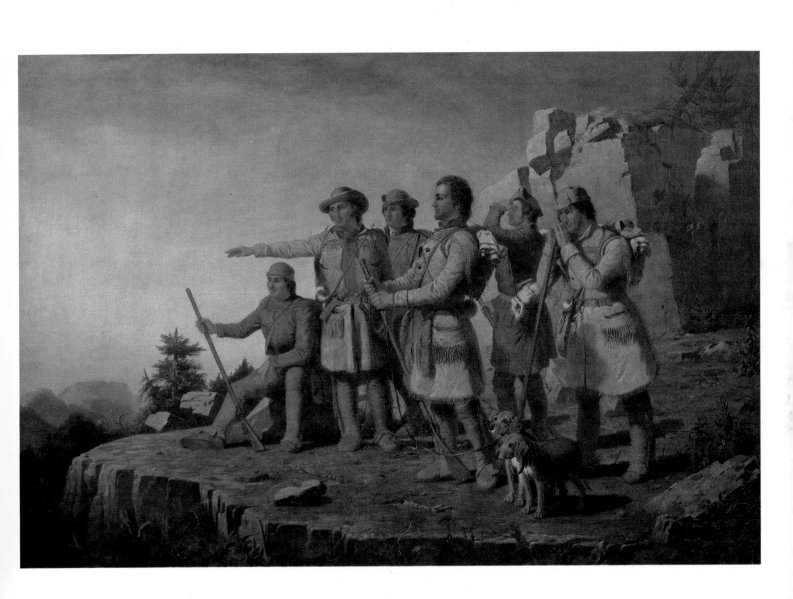

Arthur F. Tait (1819–1905)

THE CHECK

IN 1837 JOSEPH MEEK, a trapper in the Northern Plains, was involved in a series of armed conflicts with the Blackfeet Indians. Meek's battle with the Blackfeet was motivated by his desire to avenge the death of his friend, Manhead, a leader among the Delaware who had been killed by the Blackfeet. In 1850 William Ranney's painting of Meek's encounter with the Blackfeet, *The Trapper's Last Stand*, was distributed as engravings by the American Art-Union and the Western Art-Union and as a lithograph by Currier and Ives. The Meek-Blackfeet conflict became part of the popular history of the American West, and it became the subject of paintings by John Mix Stanley, Charles Deas, Louis Maurer, and Arthur F. Tait.

Arthur F. Tait painted companion pieces, which were distributed by Currier and Ives: *The Prairie Hunter—One Rubbed Out* in 1852 and *The Check—Keep Your Distance* in 1853. The Tait paintings were drawn on stone by Louis Maurer. Neither Tait nor Maurer had been West to see the land, the people, or the events they portrayed, yet the Currier and Ives prints were conceived of as colored pictorial records of current events, and they were cherished as historical documents by the print-buying public of the day. Although he had never traveled further west than Chicago, Tait's Western paintings were based on existing paintings, library research, reports of those who had traveled or had lived in the West, and his imagination. Tait's painting of the heroic trapper making a valiant stand against the Indians helped establish several stereotypes of the American West—the rugged frontiersmen, the Indian as a barrier to civilization, and the dangers of life in Indian country.

Born in England, Tait while still a young man had the opportunity to see the Indian Gallery of George Catlin when the paintings were exhibited in London. In 1850 Tait arrived in New York, where his initial success was based on his work as an animal painter. His favorite subjects included animal life from the barnyard to the wilderness, outdoor life in the Adirondack Mountains, and Western adventure.

Oil. 30 × 44 in.

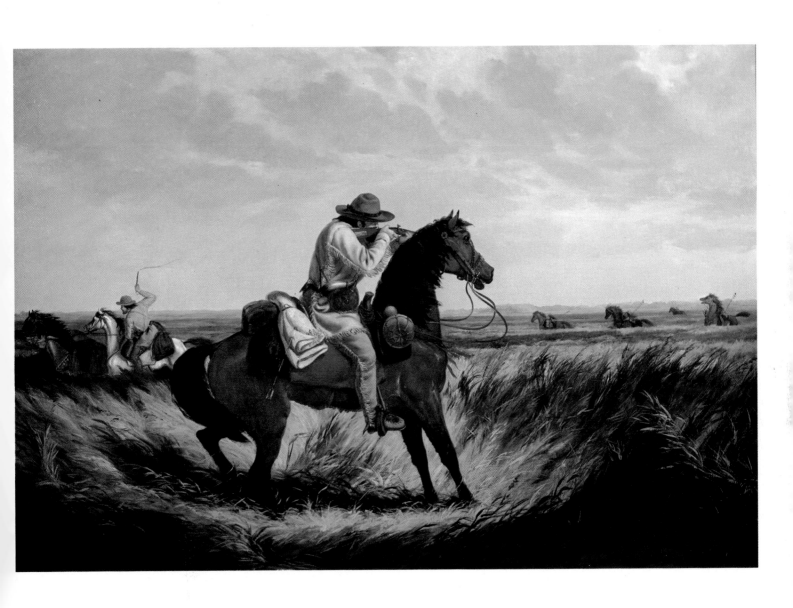

Emanuel Leutze (1816–1868)

WESTWARD THE COURSE OF EMPIRE
TAKES ITS WAY

IN 1859 THE UNITED STATES Congress commissioned Emanuel Leutze to decorate a wall of the Capitol with a mural, *Westward the Course of Empire Takes Its Way*. The title, originally written by Bishop George Berkeley in a poem, *On the Prospect of Planting Arts and Learning in America*, expresses the belief in the equation of western expansion with the inevitable progress of civilization. This is a key to the belief in Manifest Destiny and the driving force of the settlement of the American West. Nineteenth-century Americans had faith that the settlement of the West would bring the gift of civilization to the wilderness and progress to the noble savages who inhabited it.

Leutze's mural in the Capitol is more detailed than the oil study in the Gilcrease; however, the basic iconography is the same. A band of pioneers have reached the top of a mountain pass, where they self-consciously contemplate and celebrate their first view of the promised land. Their leader points their way to the future, the paradisiacal land of the West.

A century later this scene was described as "Civilization approaches the Indian with a bottle in one hand, a treaty in the other, a bludgeon under her arm, and a barrel of whiskey in her wagon." (Paul Rosi and David Hunt— *The Art of the Old West*). Such a statement expresses the revaluation in the mid-twentieth century of the belief in Manifest Destiny and recognition of the price paid by the Indians for the white man's civilization.

Born in Emigen, Germany, Emanuel Leutze earned a reputation as a teacher and a painter of historical subjects in the grand theatrical manner known as the Düsseldorf style. Leutze visited America in 1851 and in 1859, on receiving the mural commission, returned to America to travel in the West, experience the wilderness, and develop a feeling for the land and the people.

Oil. 30 × 40 in.

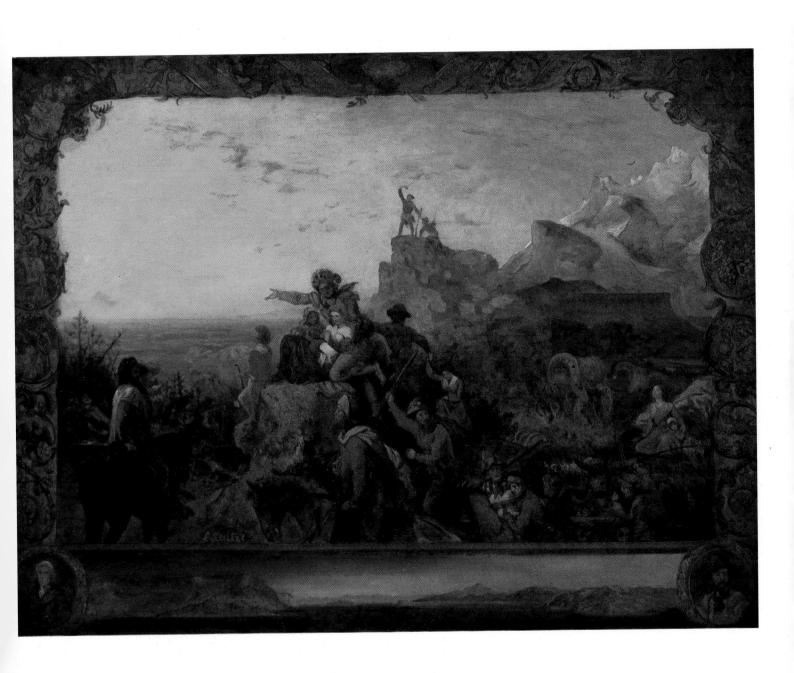

Samuel Colman (1832–1920)

WAGON TRAIN

THE PAINTINGS OF SAMUEL COLMAN document the trains of Conestoga wagons, which crossed the prairies, the great mountain ranges, and the deserts, carrying settlers and freight to the West. Known as prairie schooners, they were built in the Conestoga Valley of Pennsylvania. Before the completion of the railroad, the Conestoga wagon was the principal means of transportation across the continent. Drawn by horses, or preferably oxen, the Conestoga wagons had heavy wheels, great wooden bodies, and canvas tops supported on bows of bent white oak.

The family, along with cattle and other livestock, trudged alongside the wagon. All of the family's possessions were piled into the wagon. They carried their food—which they supplemented by hunting and fishing—tools, and weapons for defense against Indian attack. To have maximum protection against Indian attack, many pioneers joined a caravan, supervised by a captain or wagon boss. At dusk the wagons formed a circular corral so that the cattle would not be stolen or stampeded during an attack.

The wagon journeys were long and dangerous. The trails were bordered with the graves of those who died along the way, with possessions discarded as too heavy for the tired animals, broken wagons, and skeletons of horses and oxen. The caravans left early in the spring as soon as there was grass to feed the animals, and the travelers hoped to arrive before the snows of winter. Some caravans were caught in the snows and were forced to halt for the winter.

Colman made his first tour of the West about 1870. In *Wagon Train*, he did not portray the drama and danger of an overland adventure. Instead he chose to portray a scene of daily life during the long journey.

Oil. 10 × 18 in.

William de la Montagne Cary (1840–1922)

CANOE RACE

Indian tribes of both the northeast woodlands and the northeastern plains enjoyed competitive boat races. Members of neighboring tribes would travel great distances to watch the spectacle. Those on the shore encouraged their favorites by cheering and firing guns. Many of the spectators would make high wagers on the outcome of the race. Many tribes made their canoes by stretching birchbark over light, strong cedar frames. Birchbark was suitable for canoes because the bark peeled off the tree trunk in great slabs and was so heavily charged with resin that it was practically waterproof. The birchbark canoes of the American Indian were unsurpassable for although they were light enough to be carried by a single man, they were buoyant enough to bear a heavy load. In those regions where birchbark was inaccessible, the canoes were hollowed from logs.

During his lifetime William Cary made two voyages up the Missouri River. In 1860 Cary, with two companions, traveled to forts Union and Benton, then continued across the mountains to Oregon. In 1874 Cary accepted an invitation from a friend to accompany the United States Government Survey of the Northern Boundary between the United States and Canada.

Cary made on-the-spot sketches, which he later used as the basis for finished oil paintings. Today the sketches and oils of Cary's two voyages serve as a documentary record of the river life of the Missouri frontier in the days before settlement. Cary not only painted scenes of traditional Indian activities, he depicted all aspects of the river-based trading culture of the Indians before the Civil War.

Oil. 12 × 30 in.

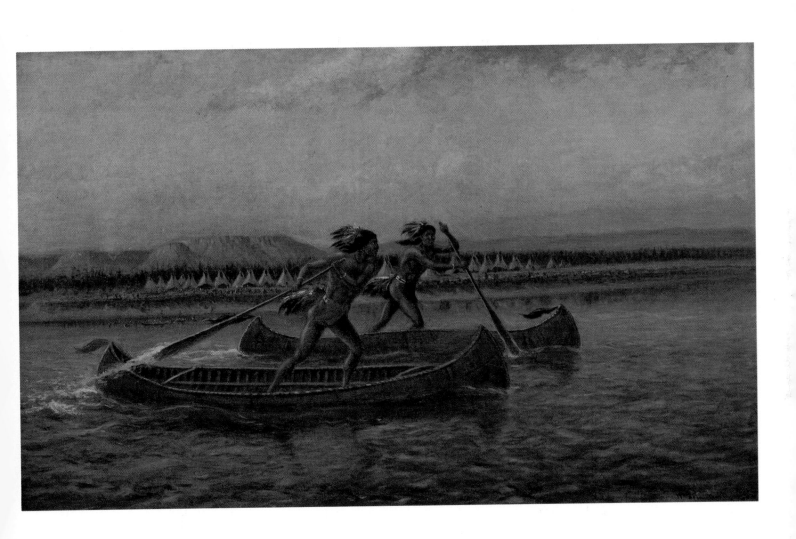

William de la Montagne Cary (1840–1922)

BUFFALO BILL ON CHARLIE

Both in life and in legend, William F. Cody—known as Buffalo Bill—was one of the most popular heroes of the American West. Iowa-born Cody served as a scout in the Indian wars and in the Civil War. He sought his fortune as a gold prospector, found employment as a pony-express rider, and won renown as a buffalo hunter.

William Cody would have been forgotten as just another Indian scout and buffalo hunter if Ned Buntline (Edward Z. C. Judson) had not met Cody while traveling in the West looking for material for popular Western adventure stories. Buntline wrote a series of cliff-hanging "true" stories about Cody, which were published in the *New York Weekly*. Buntline dubbed Cody "Buffalo Bill," then wrote and published a series of his adventures which became the first dime novels. Buffalo Bill became a superhero of the West—big game hunter, Indian fighter, and protector of women. Cody became captivated by his own legend. He claimed that in a year and a half, using a 50-calibre breech-loading Springfield rifle, he slaughtered over 4,000 buffalo. He also claimed to have served as a scout with General Custer and to have killed and scalped Yellow Hand, the Sioux Chief—a claim that is discounted today by historians.

Fred Meader subsequently wrote a melodrama, *Buffalo Bill, King of the Border Men*. In 1872 Buntline arranged for Cody, along with Wild Bill Hickok, to star in *Scouts of the Plains*, a rewrite of Meader's play. The show had little success, but Cody's decision to take his act into a tent was the beginning of the Buffalo Bill Wild West Show.

In 1887 Buffalo Bill organized the first Wild West Show, which traveled to the major cities of the United States and the capitals of Europe. Many Europeans' knowledge of the American West was limited to the cowboys and Indians in the Buffalo Bill Wild West Show. It does not matter whether Buffalo Bill's heroic deeds were fact or fiction, for Cody's great contribution was that he introduced the romance and excitement of the American West to the world. William Cary's portrait of Buffalo Bill was painted from life.

Oil. 30 × 40 in.

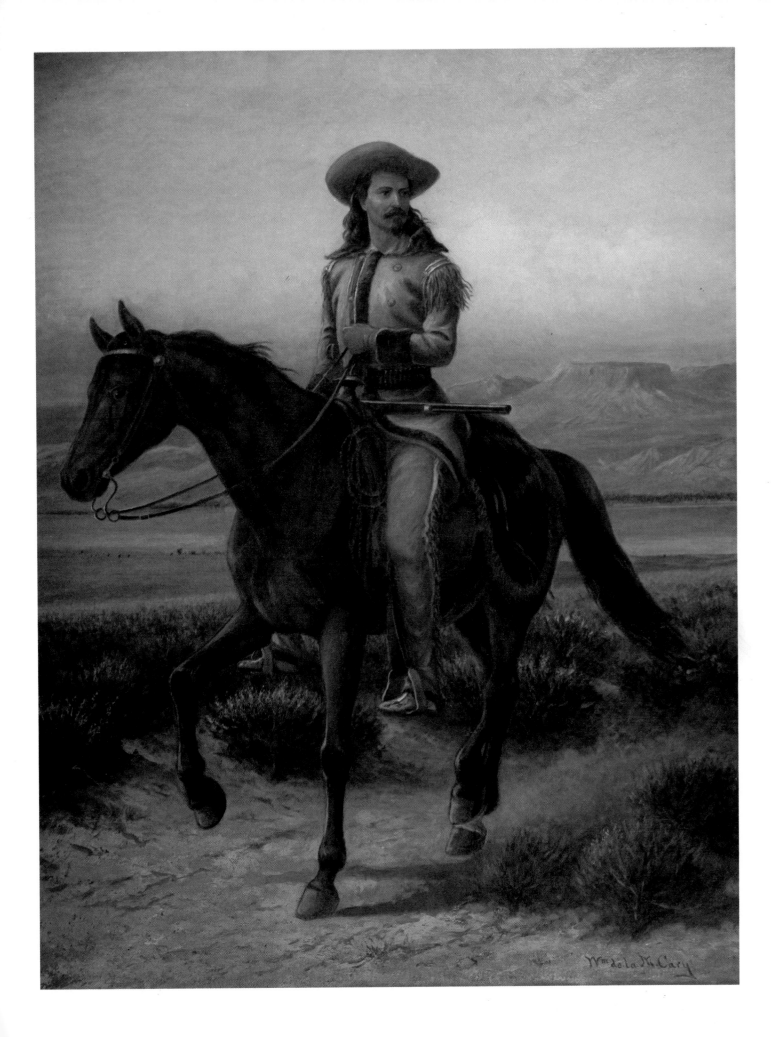

Henry H. Cross (1837–1918)

QUANAH PARKER (1880)

In THE SPRING OF 1836, Kiowa and Nokoni Comanche swept down on the stockades of Parker's Fort. They killed several of its defenders and took five captives. One captive, Cynthia Ann Parker, was between nine and thirteen years of age at the time of her capture. She became the wife of Nokoni, chief of the Nokoni Comanche, and bore him several children. By virtue of his extraordinary ability, one son, Quanah, rose to become head chief of all Comanche. The chieftainship of Quanah Parker is the only exception to inherited chieftainship in Comanche history. Cynthia Ann Parker's family begged her to return to white civilization, but she refused to leave her Indian home. In 1860 she was forcibly repatriated, and she died soon afterward.

In 1865 the Comanche and Kiowa signed a treaty with the United States which reserved for them the panhandle of Texas and other lands; however, two years later they were persuaded to accept a revised treaty providing settlement in Indian Territory. Quanah Parker refused to sign the Reservation Treaty of 1867 and remained on the buffalo plains in the area previously reserved for his people.

When buffalo-hide traders illegally invaded Indian country in the early 1870s, the Comanche fought to drive them out. The hostility spread over a five-state area, and it involved many innocent settlers and travelers. United States troops were sent to Indian country to end the hostilities, and Quanah Parker, after leading a desperate resistance at Adobe Wells in the Texas panhandle, surrendered in 1874. After his surrender, Quanah Parker devoted his life to teaching his people to survive under the hardships of agency life and to learn the white man's ways. In later life he became a rancher. In 1903 Parker rode in Theodore Roosevelt's inaugural parade.

During his lifetime Henry H. Cross painted over two hundred Indian portraits. He lived among several tribes; however, his interest was in costumes and ornaments rather than in the traditions and culture of the people. He painted most of his portraits from life, and his success was based on achieving accurate facial likenesses. Cross also completed portraits of such well-known figures of the West as Wild Bill Hickok.

Oil. 60 × 36 in.

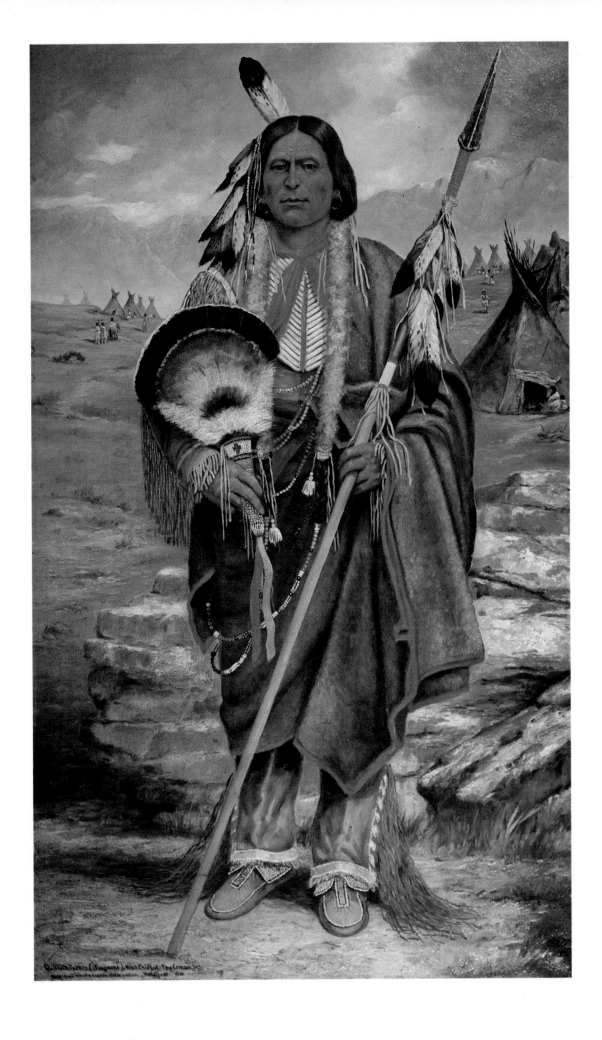

Charles C. Nahl (1819–1878)

SOUTH IDAHO TREATY

O<small>N THE BOTTOM OF</small> *SOUTH IDAHO TREATY* is inscribed: "Painted by Charles C. Nahl on the occasion of Governor Lyon's Treaty with the Sho-Sho-Nee Indians by which Southern Idaho was ceded to the United States, March A.D. 1866." By the terms of this treaty, the Indians agreed to cede to the United States millions of acres of land comprising a large part of southern Idaho and to "concentrate" upon a reservation of moderate dimensions where they would be furnished with "the usual aids for improvement and civilization."

Nahl chose to record for posterity a treaty that was never considered for approval by Congress (a treaty with the Shoshonee was not approved until June, 1867), and the negotiations for the treaty were entrusted to a man, Caleb Lyon, Governor and Acting Superintendent of Indian Affairs of the Idaho Territory from 1864 to 1866, whose career was described in an 1866 Commissioner's report as "involved in quarrels, political or otherwise, to an extent which resulted in his leaving the territory last spring, having accomplished little, if anything, to the advantage of the Indian service; and, on the contrary, failing to account for the large amount of government funds placed in his hands, causing great embarrassment to the office. . . ."

Nahl's painting is of greater interest today than at the time of its execution, for it documents the confusion and lack of comprehension of those attending the signing. None of the Indians look at Governor Lyon, at the treaty, or at the great piles of trade objects. The expressions on the faces of the Indians vary from vacant stares to anger or disinterest. It was under similar conditions that hundreds of treaties were signed, treaties in which the Indians relinquished their rights to millions of acres of land. Here ironically, has been preserved a moment of history, which in all probability would have gone unrecorded to be forever forgotten. Today this painting testifies to the corruption and lack of communication that prevailed during the era of Indian treaties.

Charles C. Nahl, a German immigrant, arrived in California in 1850 with his half-brother Hugo to participate in the gold rush, and they stayed to record the West of the mining camps. In later years Charles designed the bear on the California flag, and Hugo designed the California seal.

Oil. 27 × 37 in.

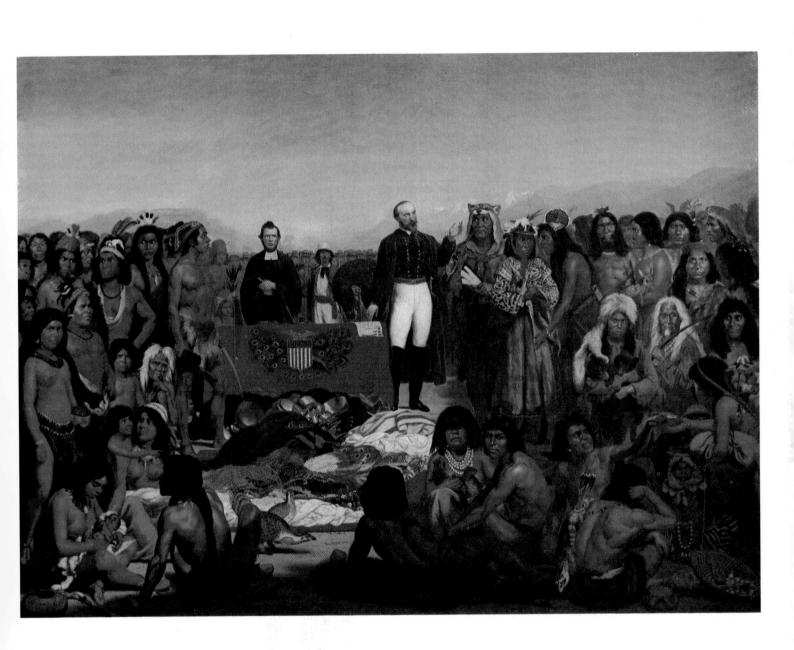

Sydney Prior Hall (1842–1922)

LAST INDIAN COUNCIL HELD ON CANADIAN SOIL BETWEEN THE GOVERNOR-GENERAL OF CANADA AND CROWFOOT, CHIEF OF THE BLACKFEET INDIANS, 1881

FOLLOWING THE EXTINCTION of the buffalo, the Plains Indian tribes desperately tried to adjust to the deprivations of reservation life. The Indians felt cheated of their lands and their means of self-support and survival. Because of the Depression of 1879–82, the Department of Indian Affairs had reduced food supplies and money intended to help the Blackfeet. In 1881 John Douglas Campbell (the Marquis of Lorne, Ninth Duke of Argyle, Governor-General of Canada) met with the Blackfeet on the broad flat land near Blackfoot Crossing on the Bow River in what is now the province of Alberta. The governor-general used the powwow, or council, as his means of contact with the Indians.

Sydney Prior Hall's major achievements as an artist were as a reporter of diplomatic missions and royal tours. In 1878, Hall accompanied the newly appointed governor-general on a trip from Liverpool to Ottawa for a promotional tour of the western provinces of Canada. Western Canada was thought of as a remote wilderness, and the young governor-general believed his tour would encourage settlement and investment and extol the virtues, opportunities, and resources of the Canadian West.

In 1881, Hall made a second visit to North America, a three-month journey that covered over 6,000 miles. After returning to England, Hall was commissioned to paint a large oil of the council between the governor-general and the Blackfeet chief, one of the historic highlights of the tour. In the painting the Marquis is seated beneath the protective canopy facing Crowfoot, Chief of the Blackfeet. All of the dignitaries in the painting are identifiable.

Oil. 54½ × 94 in.

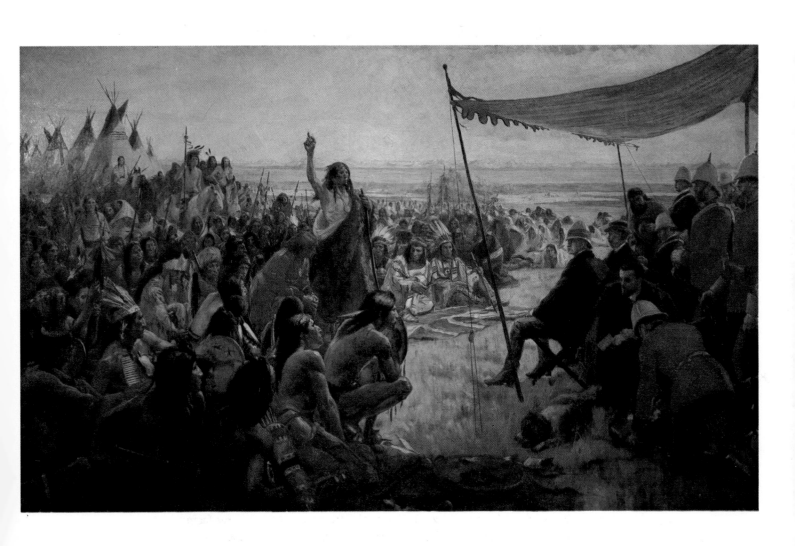

W. Gilbert Gaul (1855–1919)

ISSUING GOVERNMENT BEEF

By the end of the nineteenth century, the culture of the Plains Indians had been completely destroyed. Reduced to a state of total dependence, the Plains Indians were forced to rely on the United States government even for their ration of food. It was the slaughter of the buffalo that led to the final defeat of the Plains Indians. In 1875 General Phillip Sheridan said of the buffalo hunters: "These men have done in the last two years, and will do more in the next year to settle the vexed Indian question, than the entire regular army has done in the last thirty years. They are destroying the Indian's commissary."

Deprived of their source of food, clothing, and shelter, the Indians in Gilbert Gaul's painting sit on a hillside, clothed in the cast-off apparel of their conquerors. Their posture is that of dejection and hopelessness. One Indian, carrying a parfleche and a peace pipe and wearing a few feathers, plays the flute. Those seated nearby listen to the flute melody and remember the days when they were free to hunt the buffalo. The horses hitched to a buckboard are a reminder of the time when the Indians, proud of their land and their culture, rode their horses across the land. These horses, like the Indians, have been forced to work in the white man's world, and theirs is a destiny of movement without destination. The only evidence of freedom in the painting is the flight of the birds in the sky. Cut-up beef lies drying in the sun, awaiting distribution. In the foreground of the painting, the life of the defeated Indian has been reduced to that of a domesticated dog dependent on the goodwill of his master for food and shelter.

In the 1880s, Gilbert Gaul traveled and lived in the West in order to study the conflict between the military and the Indians. During this time Gaul was employed by the United States Indian Agency as a special agent. After his journey he illustrated several magazine articles on military action against the Plains Indians. Gaul was particularly interested in military training and combat and painted many battlefield episodes. *Issuing Government Beef* is a sobering portrait of defeat.

Oil. 30 × 42 in.

64

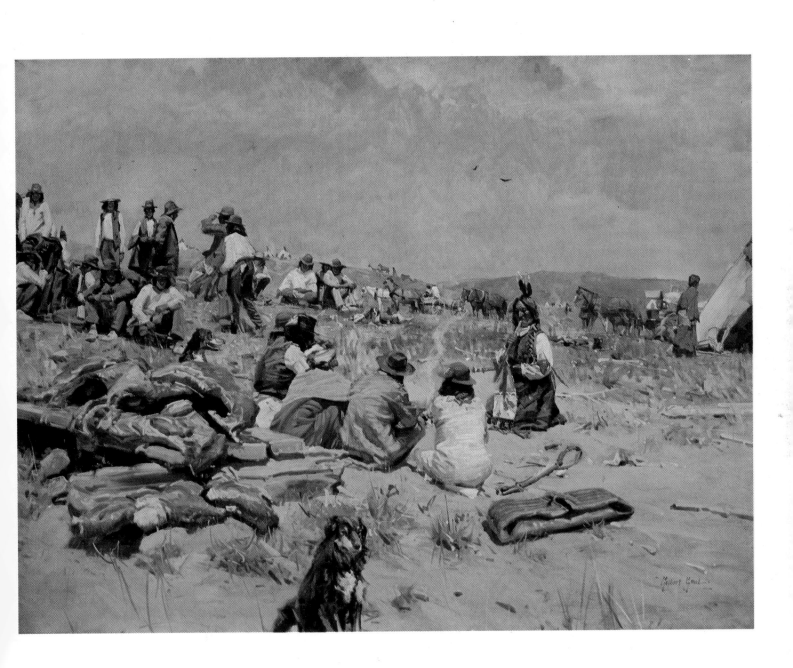

John Hauser (1859–1918)

SIOUX CAMP AT WOUNDED KNEE (1904)

WOUNDED KNEE WAS THE SITE of the agency for the Brulé Sioux on the Rosebud Reservation. By the late 1880s the Sioux living on the reservation were starving. The buffalo had been destroyed, and the cattle given to them by the white man were diseased. Their crops had failed, and diseases—unknown before the arrival of the white man—threatened them with extermination. Only the promise of a Paiute visionary, Wovoka, offered the Sioux hope of salvation.

In 1870 Wovoka's father, Tavibo, had had a revelation that all the people of the Earth would be destroyed, but at the end of three days the Indians would be resurrected in the flesh and live forever. Wovoka promised that if the Indians danced the Ghost Dance continually everywhere, the white man would be destroyed, all the Indians' ancestors resurrected, the buffalo reappear, and the prairies returned to green. The Ghost Dance would enable the Indian to return to the happiness and prosperity of the past.

The Ghost Dance was passed from tribe to tribe, and in the Spring of 1890, the Sioux began to dance in a sacred shirt, which was painted blue and decorated with thunderbirds, bows and arrows, suns, moons, and stars. The Sioux believed that if an Indian wore this shirt, which was thought to be bulletproof, he would be immortal.

The times were ripe for a showdown with the Sioux, for the settlers were anxious for their land. The press dramatized tales of horrors committed by savages who practiced the primitive rituals of the Ghost Dance. The Seventh Cavalry, humiliated by Sitting Bull in the Custer battle of 1876, blamed Sitting Bull for the frenzied dancing. Before dawn on December 15, 1890, the Indian police were authorized by the reservation agent to arrest Sitting Bull. Sitting Bull's followers tried to rescue him, but the Indian leader was killed. The myth of the infallibility of the Ghost Shirt was destroyed. The defeat of the Sioux at Wounded Knee and the death of Sitting Bull marked the final defeat of the Indian. Today Wounded Knee has become the symbol of injustice against the Indian.

John Hauser, a Cincinnati artist, became interested in the Indian in 1891 when he traveled in Arizona and New Mexico.

Watercolor. 12 × 20 in.

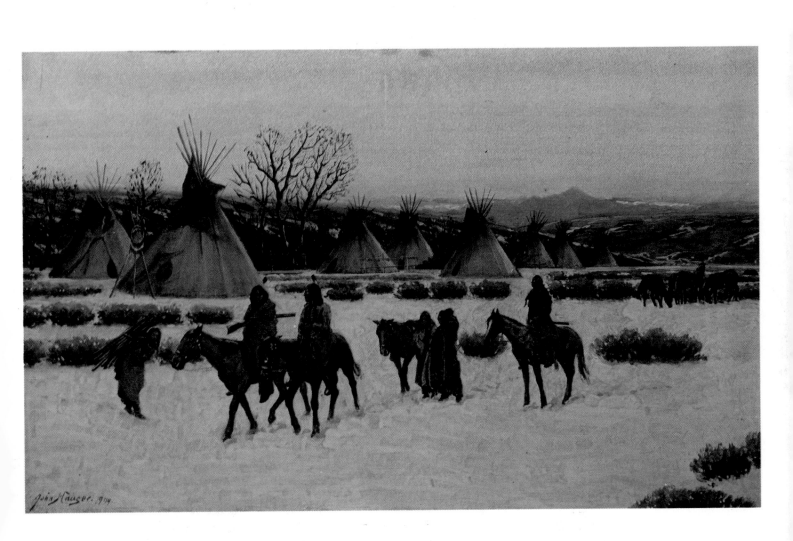

Thomas Moran (1837–1926)

PUEBLO OF ACOMA (1913)

The Acoma Pueblo is a village atop a sheer cliff, which rises 357 feet above the plains of New Mexico. The adobe houses—some three stories high—are made of mud that Indian inhabitants carried up the cliffs. The Acoma Indians have lived in their village for centuries. In 1540 Francisco Vasquez de Coronado led an expedition to the Southwest in search of the riches of the Seven Cities of Cibola. In the course of his travels, Coronado dispatched Hernando de Alvarado to find the Pueblo of Acoma. Alvarado and his men found the pueblo and scaled the rocks to the village. But they were disappointed to learn that there were neither gold nor gems in the ancient village.

In 1598 the Spanish crown gave royal approval to Juan de Onate for the conquest in the name of Spain of all Indian settlements in the Spanish provinces and awarded Onate a contract for the colonization of New Mexico. Onate assembled a party of soldiers, about 400 colonists, Franciscan missionaries, and Mexican-Indian servants. Onate proceeded to the Rio Grande pueblos and to the western pueblos of the Zuni, Hopi, and Acoma to demand formal submission to the crown of Spain. In return, the Spaniards offered the Indians protection from their enemies and salvation through baptism.

The village of Acoma vowed token submission to Onate, but the village leaders were unwilling to accept Spanish domination. Zutuapan, one of the leaders, planned the killing of Onate and, by pretending friendship, allowed Juan Valdivar, Onate's aide, to enter the village. A battle ensued, and Valdivar and several of his soldiers were killed. In 1599 Onate sent 70 soldiers to Acoma on a punitive expedition. The soldiers isolated the mesa, seized and burned the village, killed hundreds of Acomans, and captured 500 men. Those men were sentenced to have one hand chopped off and to serve 20 years at hard labor. Following this defeat the inhabitants of Acoma split into two groups. Those willing to accept domination by the Spaniards settled in the plains at the base of the mesa; the others rebuilt the village on the mesa and remained hostile to the Spaniards.

Thomas Moran painted the beauty of Acoma "Sky City" as it appeared to Alvarado and his men as they approached the mesa dreaming of a fabled world of riches. Only bloodshed and destruction would result from Spanish contact with the Pueblo.

Oil. 20 × 30 in.

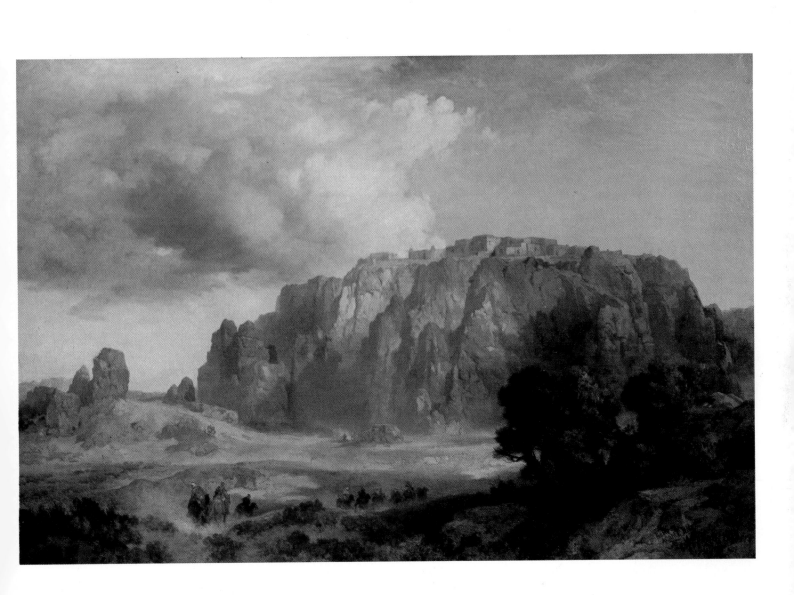

Thomas Moran (1837–1926)

THE GRAND CANYON (1913)

In 1873 Thomas Moran joined field scientist, soldier, and explorer Captain John Wesley Powell, as official artist on a survey of the Colorado-Plateau Province. In 1870 Powell, who had lost his right arm in the Battle of Shiloh during the Civil War, was the leader of the first expedition to successfully explore the Colorado River and its tributaries. In the course of the Colorado-Plateau expedition, Moran made a boat trip down the Grand Canyon. Throughout his life Moran returned again and again to that area, and his paintings of the canyon are among his most poetic, eloquent, and majestic landscapes.

In 1871 Moran joined F. W. Haden as guest painter on a government-sponsored survey party of the area of the Yellowstone River. Moran and the photographer W. H. Jackson made a pictorial record of the Yellowstone country that was instrumental in Congress' decision in 1872 to establish America's first national park, Yellowstone, and the Park Service to maintain it. Today the majority of these areas which Moran frequently painted have been preserved in their natural state for future generations as National Parks.

Thomas Moran devoted his career to painting the American landscape. Throughout his life Moran had the ability to portray the grandeur, power, and drama of the mountains, rivers, and canyons of the American West.

Born in England, Moran grew up and was educated in the United States. On completing his formal education, Moran traveled to England to study the art of Europe's master landscape painters. The work of J. M. Turner had the strongest influence on his work. From a study of Turner and Turner's model, Claude Lorrain, Moran learned to capture on canvas the color and atmospheric beauty of the land.

Thomas Moran was both poet and naturalist. He loved nature and studied the geology of each area he painted. His goal was to bring out the character of each region—the magnificent forms and the brilliant displays of color. Moran, like Bierstadt, helped to acquaint the American public with the spectacular beauty of the American West. He taught Americans to appreciate their natural heritage.

Oil. 30 × 40 in.

70

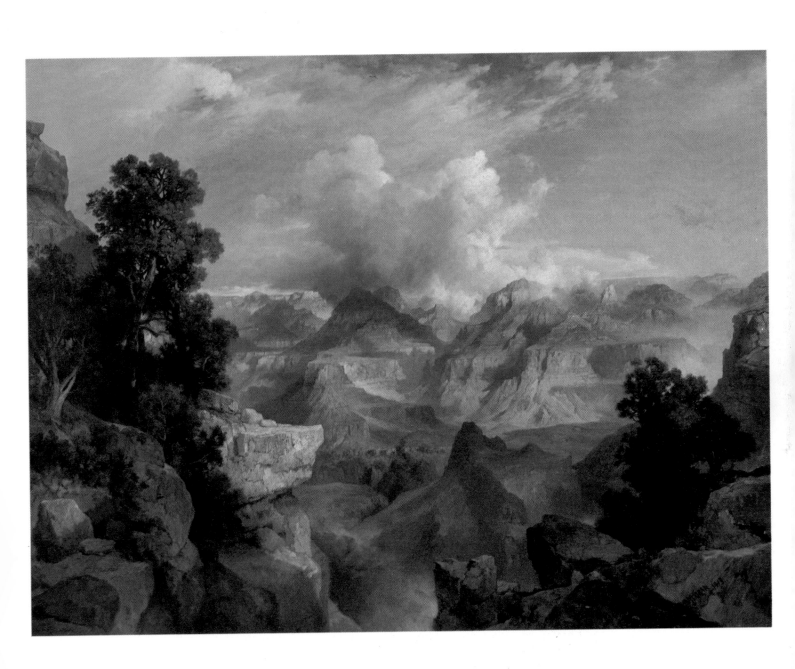

William Henry Jackson (1843–1942)

CALIFORNIA CROSSING (1867)

IN 1866 TWENTY-THREE-YEAR-OLD William Henry Jackson made an overland jour-ney by wagon train to California. Jackson worked for his passage west as an apprentice bullwhacker, receiving a wage of $20 a month. The caravan crossed the South Platte River at a spot known as California Crossing (today it is Julesburg, Colorado) and recorded the crossing in his diary of the journey: "The river here is about half a mile or a little less in width, and the greatest depth across the ford would not exceed between 3½ or 4 feet in depth. The bottom was a quicksand and gravel that makes very hard pulling. We uncoupled our wagons and fastened 12 yoke to each single wagon. The scene was a lively one. The river was filled from bank to bank with trains passing over and oxen recrossing for another wagon. The drivers as a general thing were minus pants and attired in the light and airy costume of shirt and hat only. The bulls when they first enter the stream are timid and it is extremely hard work to get them started, and the yelling, the hooting, the hurrahing and the cracking of whips of the drivers made a very pandemonium. The cattle plunged and tugged and geed and hawed & after a deal of trouble pulled out of the first plunge from the bank of the stream. . . . At the same time there were crossing a bank of Sioux Indians, the big braves on their little ponies, the squaws leading the pack horses and juvenile Sioux paddling along very nearly in a state of nature. The banks upon either side were covered with wagons & groups of drivers collected together to see the little Indians paddle in the water & chatter with the older ones. A little ways back were quite a number of wigwams. The scene was one to be remembered and I must represent it pictorially."

In later years Jackson became one of the most distinguished photog-raphers of the American West.

Oil. 22 × 34 in.

72

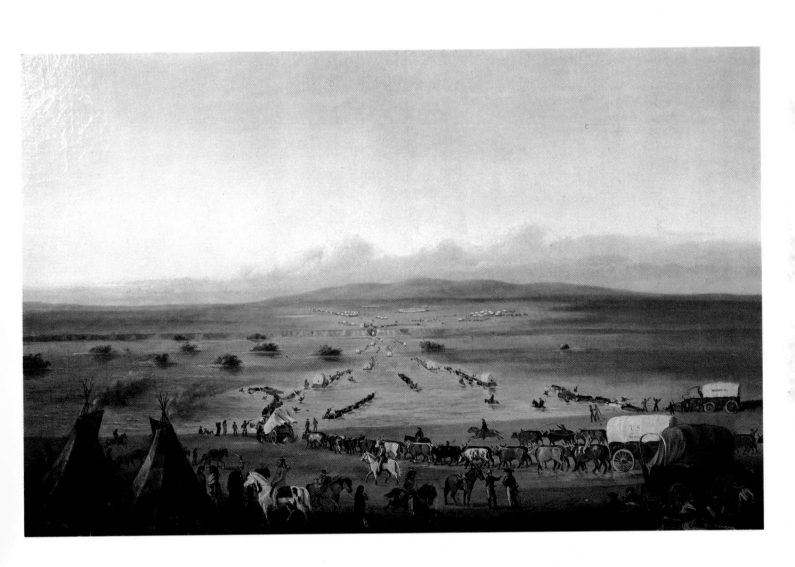

Albert Bierstadt (1830–1902)

SIERRA NEVADA MORNING

THE LANDSCAPE PAINTINGS of Albert Bierstadt helped to awaken the American public to the rich natural heritage of the American West. During the nineteenth century, Americans simultaneously cherished two conflicting views of the vast wilderness which characterized the American West. The Western wilderness was viewed both as harsh, alien, and dangerous land which must ultimately be conquered and given the gifts of civilization in order to fulfill America's Manifest Destiny; and as "God's country," a land of transcendental beauty and spiritual purity which offered Americans the possibility of salvation. The West promised regeneration on Earth—the fulfillment of the millennium.

From 1860 until the 1880s when Americans lost their taste for huge canvases, Bierstadt's giant canvases of the wonders of the Rocky Mountains inspired thousands of Americans with the sublimity of the American West. *Sierra Nevada Morning* is a pictorial rhapsody of the power, spirituality, and tranquillity of nature. The swirling storm clouds and the craggy cliffs testify to the power and dramatic intensity of nature. The mist in the middle ground suggests the mystery and spirituality of the American wilderness. The deer frolicking on the edge of the lake are symbolic of the peace, innocence, and tranquillity of nature, untouched by man.

Bierstadt was born in Germany, but he grew up in New Bedford, Massachusetts. Trained at the Düsseldorf Academy in Germany, Bierstadt returned to the United States with a love of the heroic and dramatic. In 1858, he left for St. Louis to join a military expedition led by General Frederick W. Lander to lay a wagon train route from Fort Laramie across the Rocky Mountains to the Pacific coast. In 1860 Bierstadt exhibited his Rocky Mountain paintings at the National Academy of Art, where they were hailed as a tremendous success. In 1865 Bierstadt made a second trip to the West for new material to paint. He traveled through Nebraska, Colorado, Utah, California, and Oregon.

Oil. 54½ × 86¼ in.

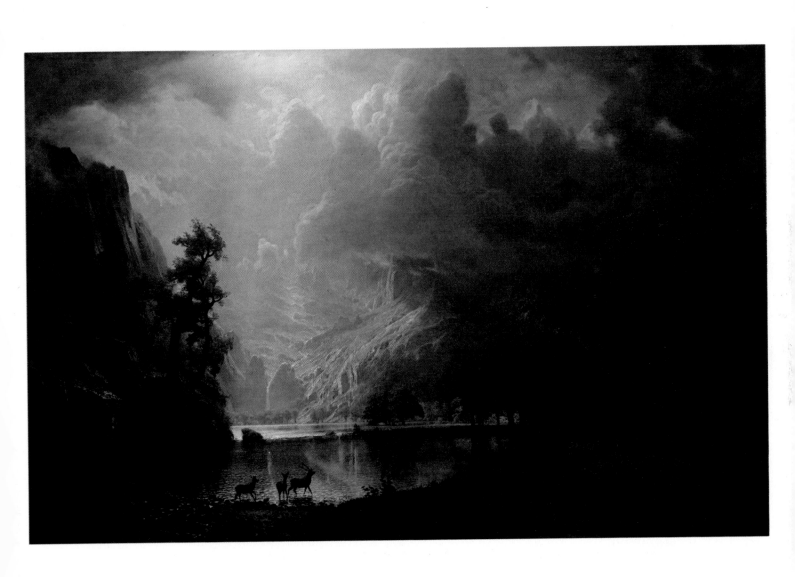

Albert Bierstadt (1830–1902)

MULTNOMAH FALLS

ALBERT BIERSTADT'S GRANDILOQUENT LANDSCAPES were the ultimate expression of nineteenth-century romanticism. The Hudson River artists had taught Americans to appreciate the beauty of the American scene and to delight in their land and its resources. Bierstadt's poetic dramatizations of western America's mountain scenery awakened the American public to the wonders of their national heritage, and they inspired in Americans a taste for the heroic.

The American landscape became not only the source of artistic inspiration but the source of a growing national pride. The soaring peaks of the Rocky Mountains symbolized America's aspirations for achievement. The awe-inspiring beauty of the American West became a basis of great national pride, and Americans identified with their land. America was a land of greatness, and it had mountains to match her men. America was the world of the hero and of the heroic landscape. In 1872 Congress passed the Yellowstone Act, which proclaimed the wonders of the American West to be a national treasure. Americans had recognized their great heritage, and they were learning to protect and preserve their land and its resources. As the century progressed, Americans ceased to see the West as a wilderness awaiting their exploration, conquest, and settlement. Instead they began to fear the vanishing of the wilderness—a wilderness characterized by scenery unmarred by man. A century later, Americans again would focus on the conservation of the wilderness and its natural resources, and they would seek the purifying powers of life in the wilderness.

In *Multnomah Falls*, Bierstadt painted a world in which man has no place. It is a world of sublime scenic beauty, bathed in a golden light. Here, along the Columbia River, are towering waterfalls, massive mountains, pine spires, and trees in an autumn symphony. The magnificent power of the American landscape became a symbol of the nation's magnificence and power. Bierstadt's painting reaffirmed the American dream of a land of spiritual purity and sublime aspiration.

Oil. 44½ × 30 in.

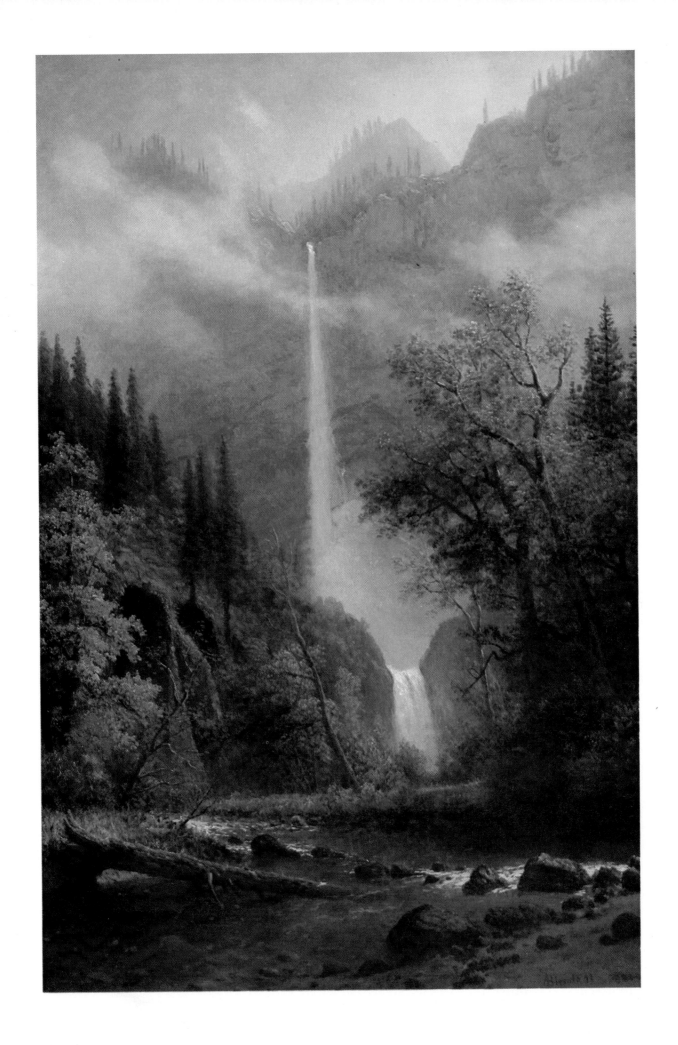

James Walker (1819–1889)

VAQUEROS ROPING HORSES IN A CORRAL (1877)

THE MEXICAN VAQUEROS of the sixteenth century—the first horsemen in North America to work cattle—were the first American cowboys. The California vaqueros, and later the Texas cowboys, adopted the methods and equipment of the Mexican vaqueros. The California vaqueros were basically Spanish gentlemen dressed in elegant and elaborate costumes. The padres, who first established missions in California in about 1770, were frequently of noble birth. Expert horsemen, these padres taught their skills to the Mexicans and Indians. The vaqueros developed great skill in roping, for they had great herds of cattle to manage. In the 1830s, after California had declared its allegiance to Mexico and the mission properties were secularized, the land was opened for development. The rancheros then became the first cattle barons of the American cattle industry.

The early California ranchers marketed only the tallow and hides of the cattle, as no market existed for beef in the eighteenth century. Since there was neither railroad transportation nor refrigeration, all beef was consumed by those who lived on or near the ranches. And the sparse population of the West required little beef.

After 1810 a series of droughts plagued California and threatened the survival of cattle ranching. To save the grasslands for the cattle, thousands of mustangs were rounded up and destroyed. But the cattle industry was irrevocably damaged. In the 1840s gold was discovered in California, and the region became a territory of the United States. Prospectors and settlers poured into California, and the golden era of the vaqueros was over.

In 1877 James Walker, an Irish immigrant, visited California and supported himself by painting scenes of the large ranchos. These paintings today are valued as colorful and accurate representations of the skills and costumes of the California vaqueros. Walker's paintings illustrate vaquero techniques and equipment, which were passed on to the American cowboy—the working saddles, the bridles and bits, the prototypes of the cowboy hats and chaps, and the *riatas* that have become the lariats of today's cowboy.

Oil. 20 × 36 in.

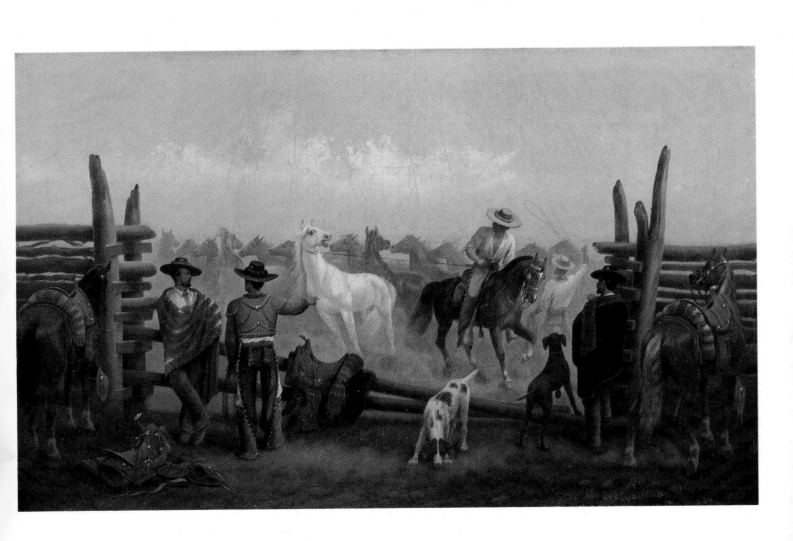

Frank Reaugh (1860–1945)

THE HERD

THE POWERFUL, ALERT, AND SELF-SUFFICENT longhorns have an unquestionable majesty, which has inspired artists and writers through the centuries. The ancestors of the longhorn were the Spanish cattle brought by the conquistadores to the New World in the sixteenth century. These big, muscular, and wiry animals with a great span of horn, ranging from 4 to over 6 feet tip to tip, were hearty foragers on the open range. They were capable of surviving wolves and mountain lions and able to thrive in semiarid country. The longhorn became a symbol of strength and survival in the West.

Spanish priests drove the longhorns to the missions they established in Texas, New Mexico, and California. By the eighteenth century the missions in the vicinity of San Antonio, Texas, raised great herds of cattle. A drought in the first half of the nineteenth century forced many cattle owners in the Southwest to abandon their herds which went wild and gradually adapted to the conditions of freedom on the range; however, as the young American nation grew, it became economically profitable to round up the wild herds and market them for Eastern consumption. After Texas joined the Union in 1845, Texans began driving their cattle eastward to New Orleans and northeast to Missouri, Illinois, and Iowa. Although the Civil War brought a temporary halt to the development of the Texas cattle industry, the herds of longhorns on the Texas plains after the war were one of the principal assets of the destitute South. The building of the railroads, the gold boom in Colorado, and the establishment of Indian reservations created a great demand for beef, and Texas cattlemen began the job of rounding up the longhorns and herding them to shipping points in Kansas and Missouri.

European settlers on the East Coast had also brought cattle with them. After the Civil War these Easterners, who were part of the growing tide of pioneers, brought their cattle west with them. The European cattle were superior in meat quality to the longhorn and, with selected breeding, were able to survive the hard life on the range. The days of the supremacy of the longhorn were numbered.

Frank Reaugh was magnetically drawn to the majestic longhorns, for he recognized that the longhorn, like the buffalo, was a symbol of the past, the vanishing Old West.

Watercolor. 14 × 35 in.

Joseph Becker (1841–1910)

SNOWSHEDS ON THE CENTRAL PACIFIC RAILROAD IN THE SIERRA NEVADA MOUNTAINS (1869)

FOLLOWING THE DISCOVERY OF GOLD in California in 1848, Congress became seriously interested in the completion of a railroad from the Mississippi River to the Pacific coast. Although the outbreak of the Civil War forced Congress to postpone plans for a network of railroads, Lincoln viewed the Union Pacific route as a necessity. He thought it would hold the Western Territory to the Union. The Union Pacific was to run from Omaha westward to California, and the Central Pacific was to run eastward from the California border. The Central Pacific, however, made faster progress than the Union Pacific. And on May 10th, 1869, the two railroads met at Promontory Point, 167 miles east of Humboldt Wells, the intended meeting place. A golden spike was used to fasten the two sets of tracks. Irish immigrant laborers were the principal builders of the Union Pacific, and Chinese laborers built the Central Pacific.

The completion of the transcontinental railroad marked the true opening of the Far West. The connection of the land from the Atlantic to the Pacific by a railroad gave Americans a heretofore unrealized sense of unity. Here was the realization of their dream of Manifest Destiny. The promised land of the West was now a commercially accessible reality. The land of the future could be reached by consulting a railroad time-schedule. The American nation had entered the new era.

Joseph (Carl J.) Becker, a commercial engraver and newspaper illustrator, served as the head of the art department of the New York publisher Joseph Leslie from 1875–1900. In 1869, the year the transcontinental railroad was completed, Becker made a trip to the West on the newly completed railroad. On his return he painted several scenes based on recollections of his westward journey.

Becker's painting is dated May, 1869, the month of the meeting of the railroads. Great storms were a problem for the railroads, both on the plains and in the mountains, and they sometimes delayed travel for days. It was necessary to build snowsheds on critical points along the mountain route through the Sierras.

Oil. 19 × 26 in.

82

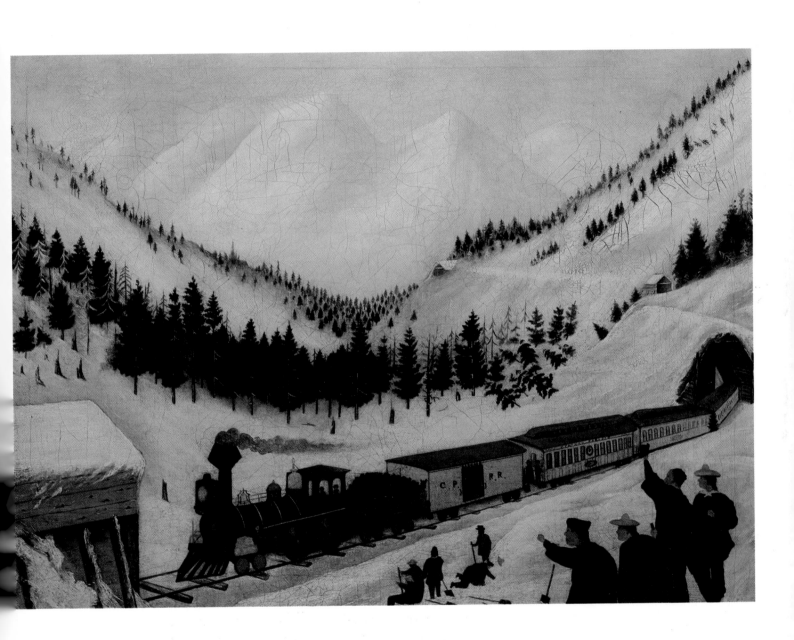

Frederic Remington (1861–1909)

INDIAN WARFARE

FREDERIC REMINGTON is the master painter of the action and excitement of the old American West. Remington was witness to the closing of the frontier, and his paintings document the heroic world of the cavalrymen, the cowboys, the mountain men, and the Indians. The Plains Indians were the finest light cavalry in American history. In *Indian Warfare* Remington depicted a dramatic moment during the attack of a Cheyenne war party on an army wagon train.

The battle is in its second phase; the first attack is over, and the soldiers are in a position of defense. The troops have formed a circle around the clustered wagons and are firing on the attacking Indians. The Indians ride at top speed around the infantry column and fire at the troopers. The Indian horses are stripped of their saddles and any encumbering equipment, and the riders carry only their weapons. The bodies of both horses and Indians are painted for battle. The ring around the horse's eye ensures unfailing eyesight, and the lightning stripes painted on the legs ensure surefootedness. During the course of this high-speed attack, the Indians try to rescue a fallen companion. This rescue necessitates skills in horsemanship which have been practiced from childhood. The rescuers use a rawhide rope under the arms of the fallen man to raise him onto a horse.

Individual daring and honor in battle were of paramount importance to the Indians, for a warrior's conduct was determined by a strict code of honor. The Indians were willing to sacrifice the efficiency of their attack to retain such honor, and their code demanded the rescue of the dead or wounded. Although the battle might be lost, the rescuers could win glory for their skill and daring and, above all, retain their honor. For the Plains warriors, death with honor on the battlefield was preferable to suffering the miseries of old age.

Oil. 30¼ × 51 in.

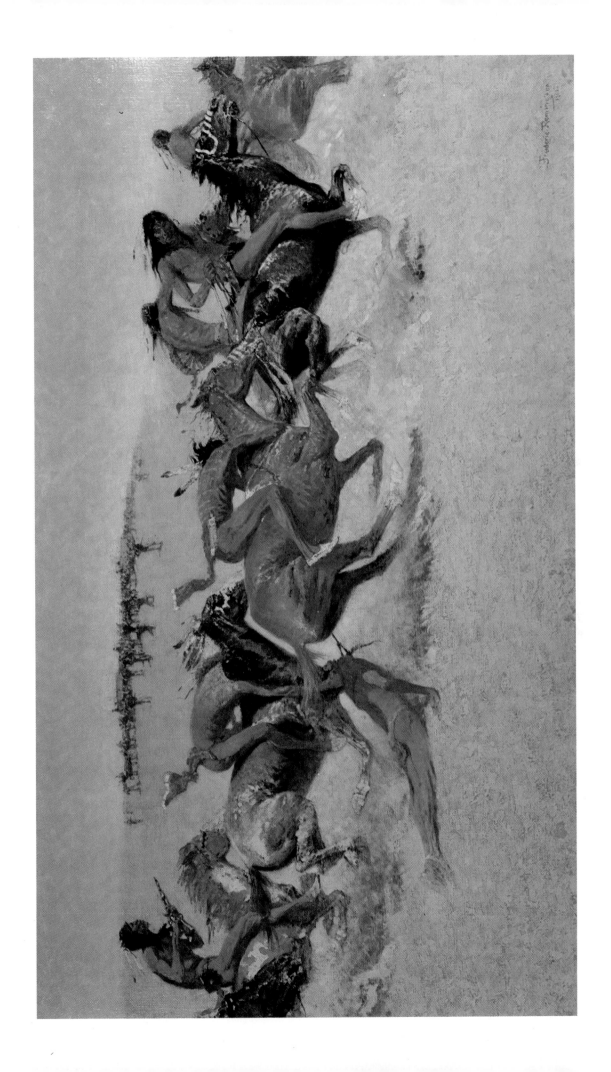

Frederic Remington (1861–1909)

MISSING

It was an unwritten rule of Indian warfare that there was no such thing as surrender. It was far better for a trooper to take his own life than be reported missing. Rather than be taken captive, most troopers saved the last round of ammunition to end their own lives. During the Indian Wars neither side took many captives. The few soldiers captured by the Indians were either taken by surprise or found wounded. The Indians, anticipating retaliation and pursuit, usually killed their prisoners soon after capture. Under certain conditions, however, the Indians marched their prisoners back to their camps in order to obtain information about the enemy. A variety of tortures were used on the unfortunate captives before they were killed.

In *Missing*, Frederic Remington captured the dignity, pride, and unwillingness to yield of both the captured cavalryman and his Indian captors. The cavalryman was the fearless and gallant defender of the West. Courageous in battle and stoic in defeat, he was the hero of many of Remington's outstanding paintings and sculptures.

Frederic Remington first traveled to the West in 1880. He traveled through the Dakotas, Wyoming, Montana, Kansas, and Indian Territory. He worked as a hired cowboy and sheep rancher; traveled over plains, desert, and mountains with a wagon train; and tried prospecting for gold. Remington visited Indian settlements and learned to distinguish various Indian tribes. He followed the footsteps of the pioneers over the Oregon and Santa Fe trails. Remington even joined a military division during the final campaign against the renegade Sioux who offered resistance to the dictates of Washington. Although Remington went West many times during his life, the experiences of his youth inspired him throughout his career. It was his artistic mission to reproduce on canvas and in bronze the West of the 1880s—the West of the cowboys, Indians, and cavalarymen.

Oil. 30½ × 51 in.

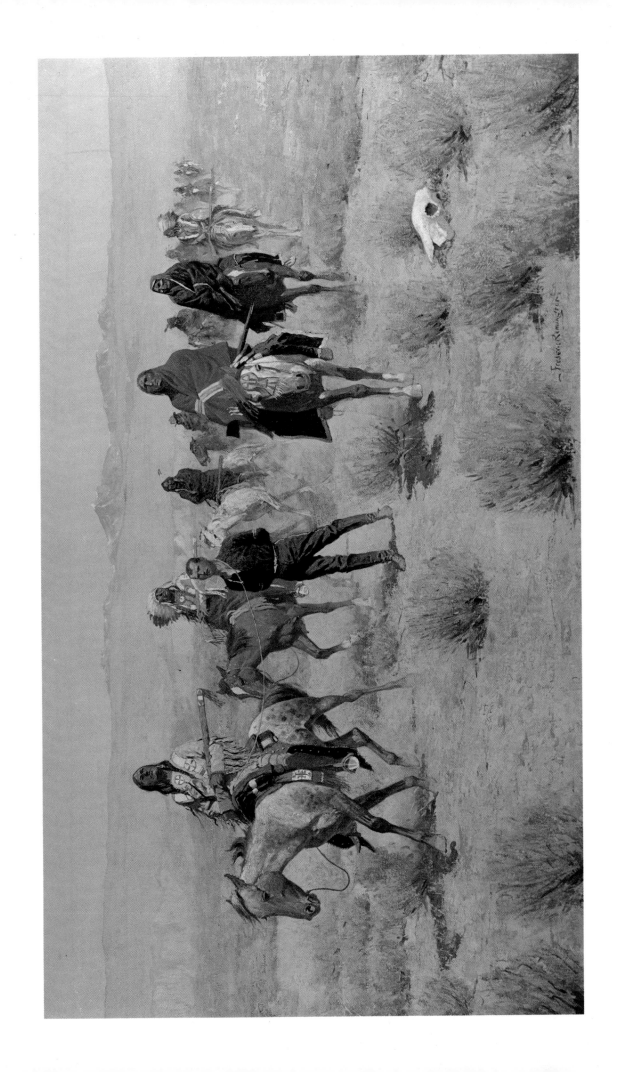

Frederic Remington (1861–1909)

THE COMING AND GOING OF THE PONY EXPRESS
(1900)

Aᴌᴛʜᴏᴜɢʜ ᴛʜᴇ ᴘᴏɴʏ ᴇxᴘʀᴇss operated for only eighteen months, the fortitude, courage, and speed of the pony-express riders have excited the imagination of generations of American artists. On April 3, 1860, riders simultaneously left St. Joseph, Missouri, and Sacramento, California, in a dramatic experiment at providing overland mail service across the plains, desert, and Rocky Mountains. A series of riders completed the transcontinental route in eight days, half the time of stagecoach mail service.

One hundred ninety stations, ten to fifteen miles apart, divided the 1,966-mile route. A rider covered at least three stations, changing horses at each station. The rider was allowed two minutes to change mounts, but well-coordinated efforts could cut the time to fifteen seconds for only the transfer of rider and saddle bags was necessary. The mail was wrapped in oil silk and was carried in four leather bags attached to the skirts of the saddle. The boxes were locked, and keys were distributed to the relay stations along the route. Twenty pounds was the maximum weight of the mail carried by each rider and one dollar per half ounce was the rate for mail service.

The pony express initially employed eighty men as riders and two hundred men to care for the animals. They utilized over four hundred high spirited saddle horses, some acquired at a cost of two hundred dollars, a fortune to spend for a horse in the 1860s.

The riders were chosen for their youth, endurance, and courage. An advertisement that appeared in San Francisco a month before service began read: "WANTED: Young skinny wirey fellows, not over eighteen. Must be expert riders willing to risk death daily. Orphans preferred. Wages $25 per week. Apply, Central Overland Express, Alta Building, Montgomery Street." The wages included board and, depending on the risk of the segment ridden along the route, ranged from $50 to $150 a month. On October 24, 1861, the last link in the transcontinental telegraph was completed—an event that marked the end of the pony express.

Frederick Remington chose to paint a critical moment in the operation of the pony express—the split-second, precision changing of mounts at the relay station along the route.

Oil. 37¼ × 40 in.

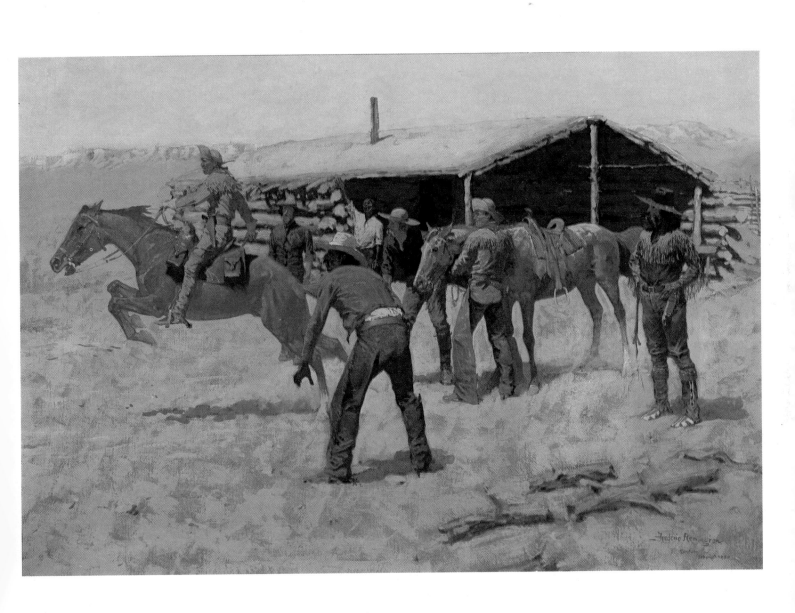

Frederic Remington (1861–1909)

STAMPEDED BY LIGHTNING (1908)

By the time Frederic Remington visited the West, the days of the great cattle drives from the ranges to the railheads were part of history. To the cowboys who worked on these cattle drives, the stampede was one of the greatest dangers. In the event of a stampede, the herder would ride through to the head of the herd and try to turn the leaders. This action would force the herd into a circle that could be tightened to ultimately halt the stampede. If the herder's horse should stumble and fall, certain death would result. Any sudden disturbance could start a stampede; for example, a bolt of lightning could spook a herd into panic.

On December 12, 1908, Remington wrote of his newly completed painting: "Regarding that picture, long ago when I was a boy I have had a few realities of that kind burned into my brain and I have at least a half dozen times tried to perpetuate the impressions on canvas but have failed and burned up the results. At last I concluded to pass the present canvas as being as near the thing as I am likely to come. . . .

"I think the animal man was never called on to do a more desperate deed than running in the night with longhorns taking the country as it came and with the cattle splitting out behind him, all as mad as the thunder and lightning above him, while the cut banks and dog holes wait below, nature is merciless."

Oil. 27¼ × 40 in.

90

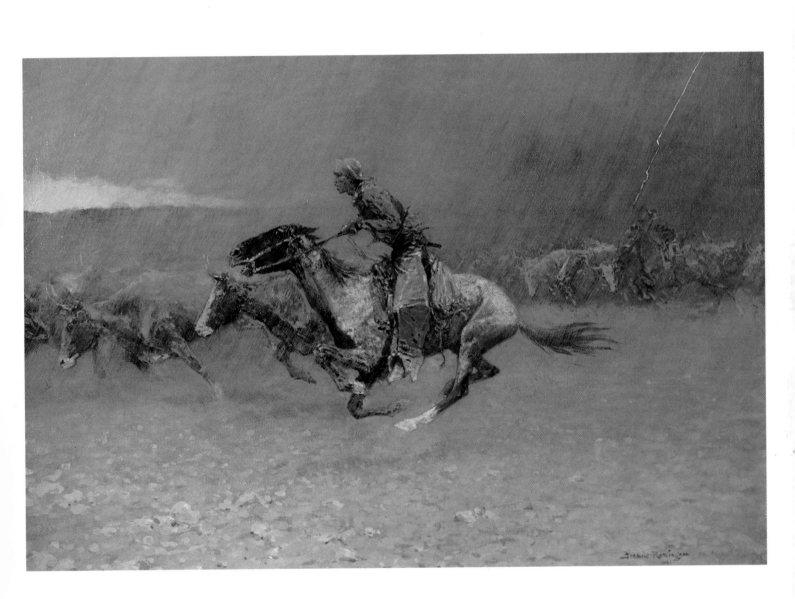

Charles Schreyvogel (1861–1912)

BREAKING THROUGH THE LINE

In 1893 Charles Schreyvogel traveled West to the Ute Reservation to be the guest of the army post's surgeon. William "Buffalo Bill" Cody, Schreyvogel's lifelong friend and admirer, had arranged the trip so Schreyvogel, who suffered from severe asthma, could regain his health. In Ignatio, Colorado, there was a regiment of United States troopers who had just returned from the Philippines. These troopers taught Schreyvogel to ride and to use a rifle cavalry style. After five months in Colorado, Schreyvogel traveled to Arizona, where he lived on a large ranch. On his return to Hoboken, Schreyvogel decided to paint a record of the violent drama between the Indians and the United States during the thirty years after the Civil War. One of Schreyvogel's greatest admirers was Teddy Roosevelt, who encouraged his work and gave him official permission to visit any army post or Indian reservation in the United States. Schreyvogel used this privilege to visit the Sioux, Ute, Crow, and Blackfeet reservations.

Many of Schreyvogel's paintings focus on the action-filled confrontations of the cavalry and the Plains Indian horsemen. Schreyvogel painted scenes of violence and high drama in the confrontation of the troopers and the Indians, the critical moments of battle—the attack, the hand-to-hand combat, the heroic rescue, and the desperate last stand. His action-filled canvases depict scenes of gunfire and death on the battlefield. Schreyvogel painted the Indians as desperate, fierce warriors—men of action fighting to the death to save their land and way of life by halting the Western migration. In Schreyvogel's paintings, the United States trooper is always the hero and victor.

In *Breaking Through the Line,* the trooper rides straight forward, aiming his revolver at the viewer's eye so that the viewer must experience the drama and excitement of the battle. Behind the leader, fellow troopers have broken through the line and thus have deadened the thrust of the Indian attack. Viewing a Schreyvogel painting is a similar experience to watching a Hollywood western, for the viewer shares the glory of the heroic cavalry in defeating the savage Indian enemy in bloody battle.

Oil. 39 × 52 in.

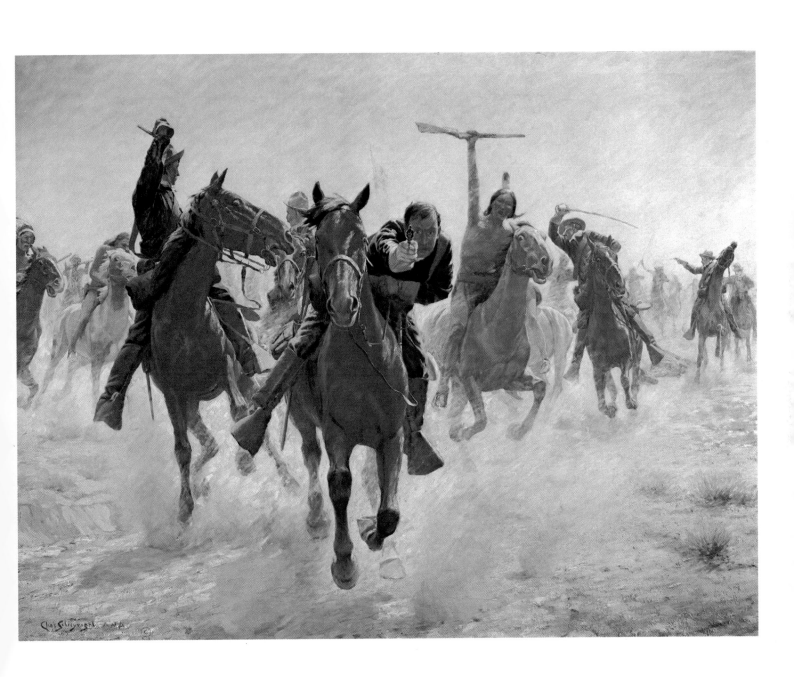

Charles Schreyvogel (1861–1912)

CUSTER'S DEMAND

IN 1868 GENERAL PHILLIP SHERIDAN took over the Department of the Missouri, which included the Great Plains from the Canadian border to the Gulf of Mexico. Sheridan, whose attitude toward the Indian was expressed in his famous statement, "The only good Indian is a dead Indian," was determined to destroy the tribes of the southern Great Plains. In 1868 he sent Lt. Col. George Armstrong Custer, who in 1867 had been suspended for misconduct and for having deserters shot, to lead the Seventh Cavalry into Indian Territory. Custer carried orders from Sheridan to kill the hostile Indians and to confine the remaining tribes to reservations.

Custer, in his search for hostile Indians, located on the banks of the Washita a village of Cheyenne led by Black Kettle, who previously had played the role of intermediary with hostile chiefs. Custer led his men in an attack on the peaceful village. His troops massacred men, women, and children; shot over eight hundred Indian ponies; and burned all teepees, buffalo robes, and tobacco. Custer was aware that below Black Kettle's village were tribes of Cheyenne, Arapaho, and Kiowa in winter quarters. Under orders from Sheridan to make one more sweep of the Washita, Custer returned and found that the Indians had fled to Fort Cobb under the protection of Colonel William Hazen. Custer turned toward Fort Cobb and was met by an army scout with a letter from Colonel Hazen which assured Custer the tribes were friendly. Custer was then met by a delegation of Indian chiefs carrying a white flag.

In *Custer's Demand*, Schreyvogel has depicted the meeting of Custer, accompanied by an interpreter, his brother Tom, a scout, and Sheridan's aide de camp. The Indian delegation is headed by Satanta—the Kiowa chief—and is accompanied by Lone Wolf, Kicking Bird, and Lone Heart. Custer informed the chief that if the Indians did not surrender and move to the reservation, they would be destroyed like Black Kettle's people. As the Indians accompanied the troops back to Fort Cobb, Custer and his men declared that Lone Wolf and Satanta, who rode in front with his delegation, were prisoners. However, those riding behind escaped. Sheridan then announced that the tribes must be on the reservation by sundown or the two chiefs would be hung. Although the Kiowa and Arapaho complied, the two chiefs were held until the following summer.

Oil. 54 × 78 in.

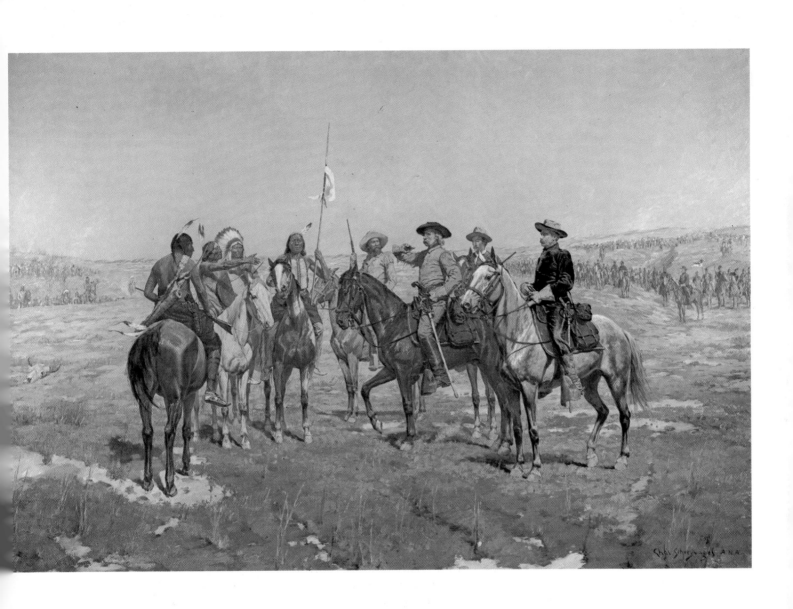

Charles M. Russell (1864–1926)

THE BUFFALO HUNT #2 (1900)

CHARLES M. RUSSELL PAINTED the world of the American West before white civilization irrevocably changed both the face of the land and the lives of the people. Russell's painting expresses the poetic beauty of the landscape and the excitement and heroic drama of Plains Indian life.

The buffalo was the focus of the Plains Indian culture. The hunting of the buffalo was one of the most important activities of Indian life, for the buffalo provided food, clothing, shelter, tools, and fuel. Before the arrival of the white man, buffalo were hunted on foot. The Indians surrounded the herd and drove them into pens or over cliffs. After the Indians adopted the horse for hunting, they began using a method in which the riders turned the herd then shot the animals trapped in the circle. In later years the Indians hunted the buffalo in a straight run. Men rode down either side of the herd then fired at selected animals. Filled with excitement and danger, the straight-run hunt demanded great courage and skill in horsemanship. The straight run was the major method of hunting until the final destruction of the great herds of buffalo at the end of the nineteenth century.

In *The Buffalo Hunt #2,* Russell painted the moment when the buffalo, having sighted the hunters, have started to run. The leader of the hunters has given the signal, and each man tries to run down the herd. The fastest horses have caught up with the herd, and as the front ranks break up, the Indians—having individually selected a target—prepare for the kill. Charles Russell painted the buffalo hunt many times. His paintings serve as a magnificent tribute to one of the most important rituals of Plains Indian life.

Oil. 49 × 73 in.

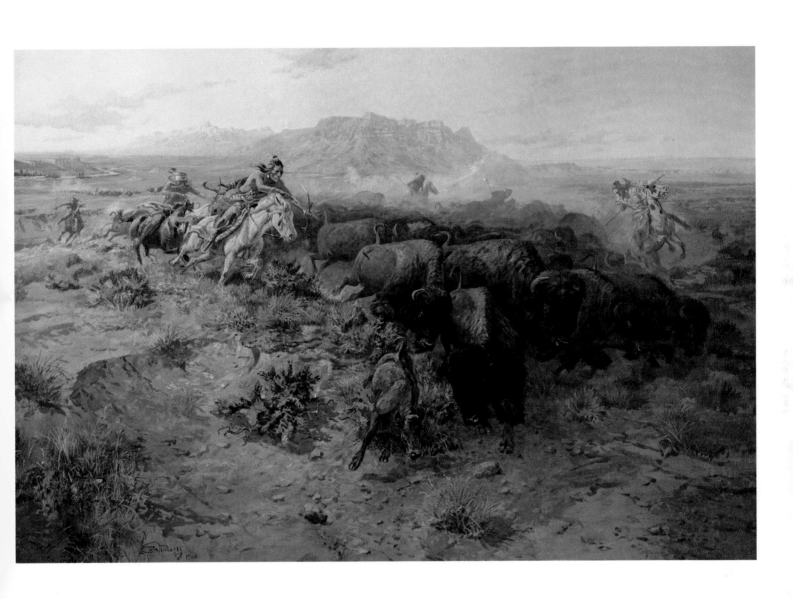

Charles M. Russell (1864–1926)

JERKED DOWN (1907)

Charlie Russell longed for the past and treasured his early days in the West. He mourned the passing of time and the resultant changes. The happiest years in Russell's life were the years spent as a cowboy in the Judith Basin in Montana. As a young man, Russell worked as a night hawk—singing to the cattle while the cowboys slept—and as a night herder of cattle. He studied every aspect of cowboy life and, in later years, recaptured in his paintings all aspects of the cowboy's work on the range. Russell's lonely life as a cowboy left him ample time to dream, draw, and model. And the observations and experiences of these years served as inspirations for paintings and sculptures throughout his life.

Jerked Down dramatizes one of the occupational hazards of cowboy life. During the roundup a steer has been roped. Another steer, however, has jumped the rope and entangled its foot in the line pulling the cowboy's horse to the ground. The cowboy, retaining a firm grip on the line, has shifted his weight to help his horse regain its balance. The other cowboys rush to the rescue. One prepares to lasso the roped steer so the cowboy can cut loose, and another one stands ready with his lasso if additional help is needed.

Charlie Russell's photographic memory enabled him to achieve authenticity of detail in his work. The accident in *Jerked Down* is the result of the "hard-and-fast" method of roping used in Montana. Using the hard and fast method, in which a rope is tied to the saddle horn, was more hazardous than using the dally rope, which could be drawn in or let out. *Jerked Down* was selected in 1964 for a United States postage stamp to commemorate the 100th anniversary of Russell's birth.

Oil. 22½ × 36½ in.

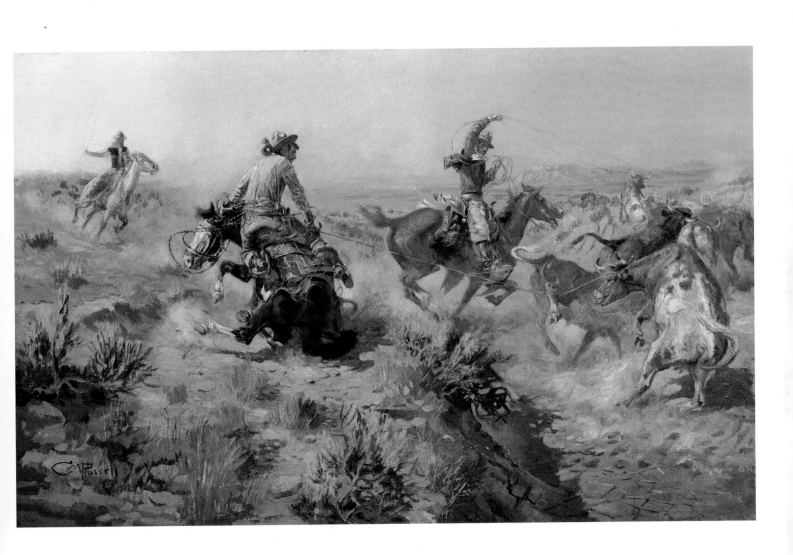

Charles M. Russell (1864–1926)

MEAT'S NOT MEAT 'TILL IT'S IN THE PAN (1915)

CHARLES M. RUSSELL WAS THE HOMESPUN philosopher of the frontier. Russell in many of his paintings shared his enjoyment of the humor and pathos of everyday life in the West. Charlie was interested in the daily activities and predicaments of the range cowboy and the misadventures inherent in wilderness life. He was also interested in painting the excitement and drama of the heroic episodes that characterized the closing chapters of Indian life in the West.

Russell was fundamentally an ecologist, believing in the harmony of nature's creatures and in brotherhood for all people—red and white. He was closer in spirit to the mountain man than to the cavalry officer or pioneer. Russell did not share the view that the God-given mission of the white man was to carve a civilized world from the wilderness. The pioneer went west to build the future, and Russell traveled west to relive the past. For two years after his arrival in Montana, Russell lived with Jake Hoover, a well-known prospector, hunter, and cowboy, who taught him the skills of survival in the wilderness. During these years, Russell made his first friendships with the Indians. These early years in the West were Russell's happiest. He never enjoyed the fruits of financial success, for the world he loved had vanished. Russell wrote: "I came west 31 years ago at that time baring the Indians an a fiew scaterd whites the country belonged to God but now the real estate man an nester have got moste of it grass side down an most of the cows that are left feed on shuger beet pulp but thank God I was here first. . . ."

In *Meat's Not Meat, 'till It's in the Pan,* Russell painted an awkward moment in the life of the solitary hunter. The ram, shot at a higher part of the slope, has fallen onto an icy ledge just out of reach. Below the ram is the gorge into which both the hunter and the ram may fall. An eagle cruises patiently, waiting to see who will enjoy the meat of the ram.

Oil. 24½ × 36 in.

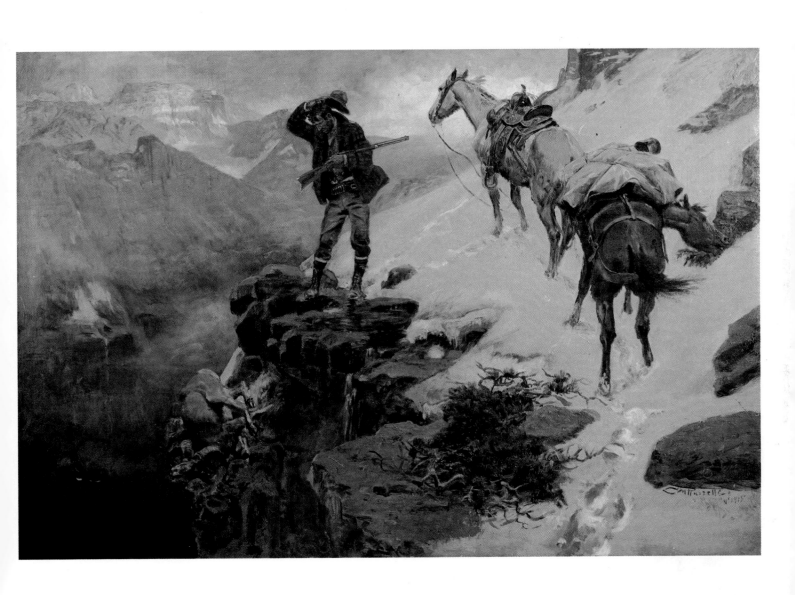

Charles M. Russell (1864–1926)

DISCOVERY OF LAST CHANCE GULCH (1925)

ON JULY 14, 1864, FOUR PROSPECTORS— John Cowan, D. J. Miller, Reginald Stanley, and John Crab—found gold in a little gulch on Prickley Pear Creek. This party of men, known as the Four Georgians, had set out from Virginia City for the eastern slope of the Rocky Mountains. Then they traveled north to the Marias River. Discouraged by reports of luckless miners and by their lack of success with panning, they decided to retrace their route to a little gulch where they had previously found traces of gold. They referred to this gulch as "our last chance."

The discovery of gold at Last Chance Gulch was the last of three Montana rushes. The first was in 1862 at Grasshopper Creek, which later became Bannack City, Montana's first territorial capital. The second was in 1863 at Alder Gulch, which became Virginia City and Montana's second territorial capital. News of the discovery at Last Chance Gulch drew scores of miners to the area, and at a public meeting in October, 1864, the new community was named Helena. Although its gold deposits were not as rich and its growth less spectacular than that of Virginia City, Helena was within a few miles of the Mullan Wagon Road, which ran from Fort Benton to Walla Walla, Washington. Helena became a distribution center for supplies going up the Missouri River to Fort Benton. Eventually it even became the center of Montana's wealth and cultural activities. In 1875 Helena was chosen as the third territorial capital, and in 1889 it was named as the capital of the new state. Main Street has now been renamed Last Chance Gulch, in honor of the city's historic birth.

Oil. 17½ × 29½ in.

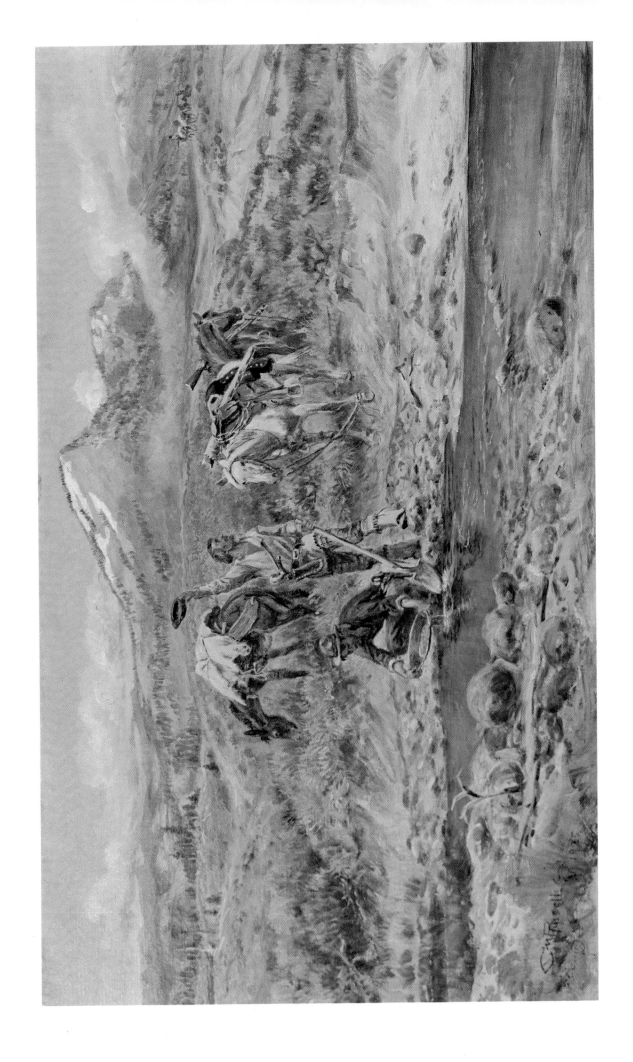

Henry Farny (1847–1916)

BREAKING A PONY (1905)

The first horses were brought to the American continent by the conquistadores. Although prior to this time the Indians had hunted the buffalo on foot, being mounted made hunting more successful and enabled them to follow the migrations of the buffalo herds. The number of horses owned by a tribesman became a symbol of wealth, and horses were used instead of currency for trade.

Indian boys learned to ride soon after learning to walk. The Indians usually rode bareback and did not use a bridle but kept a rope dangling from the horse's neck for use in an emergency. The Indians depended on their legs to balance themselves and to direct their horses for they needed to have their hands free for combat or hunting.

Traditionally, Indians mounted from the right side, but once they began to use the white man's saddle, they adopted his method of mounting from the left. In *Breaking a Pony*, Farny painted an Indian boy learning a traditional method of breaking horses. As his elders watched and supervised from the shore, the boy led the unbroken horse into deep water, where he mounted the horse by grasping the mane. He used the rope halter to hold onto the horse and to keep its head raised. The deep water limited the force of the horse's bucking and jumping and tired him quickly. After several rides into the water, most horses became accustomed to the rider on its back and were ready to be ridden on land.

Henry Farny, a Cincinnati artist, painted scenes of the everyday life of Indians—scenes of a peaceful world in which Indians lived in harmony with their environment. Although occasionally Farny painted events of the past, he preferred to depict the era after the Indian Wars but before the Indians' confinement to reservations was completed. Farny made numerous trips to the West, including a 1,100-mile canoe trip down the Missouri River in search of material for paintings. Such trips were made because he believed "the plains, buttes, the whole country and its people, are fuller of material for the artist than any country in Europe."

Oil. 21 × 32 in.

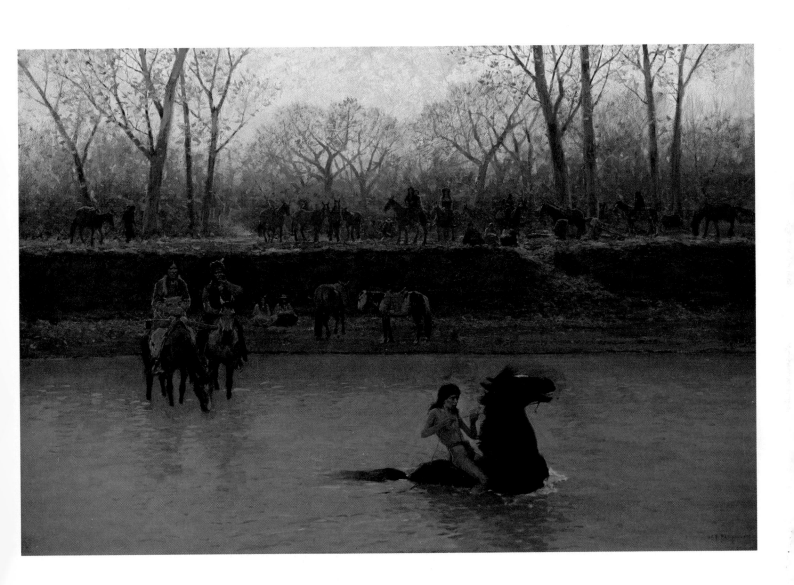

Edward Borein (1873–1945)

THE STAGE COACH (1915)

THE MULE-DRAWN COACH OF *The Stage Coach* by Edward Borein was known as the "Jackass Mail" or "Jackass Express." In 1857 the United States post office organized a line running over the Santa Fe Trail from San Antonio to El Paso and then to Yuma. The coach route from El Paso to Yuma was through hostile Apache country, and the stage was often protected by a cavalry escort. The coach used for the Jackass Express was the mud coach, or wagon, which was lighter than the Concord mail coach and better suited to the rough terrain of the West. The coach was drawn by mules, for they better withstood the severe desert heat. From Yuma westward, the way was too difficult for the stagecoach, and both the passengers and the mail continued by muleback and pack mules.

Edward Borein was born and raised in the West. Inspired by the work of Frederic Remington and his close friend, Charles M. Russell, Borein devoted his career to recording cowboy and Indian life in oil, watercolor, and etchings. Hungry for western adventure, Borein left school to devote his energy to ranch work and life as an itinerant cowboy. He traveled up and down the Pacific coast from Baja California to Oregon, across the Northern Plains and the Rocky Mountains, and into the Southwest. Borein continued to work as a ranch hand and cowboy until he was thirty-four. Then he moved to New York City to study. His studio served as an oasis for people thirsting after the spirit of the West. Frequent visitors included Will Rogers, Buffalo Bill Cody, and Theodore Roosevelt. Borein later returned to California and settled in Santa Barbara.

During his travels in Mexico, Borein traveled over 1,200 miles on the Occidental Stage Line. The Sonora stagecoach was drawn by a team of eight mules "two in the lead, four on the swing and two on the tongue." The coach averaged sixty miles a day regardless of the blazing heat or freezing cold.

Oil. 24 × 28 in.

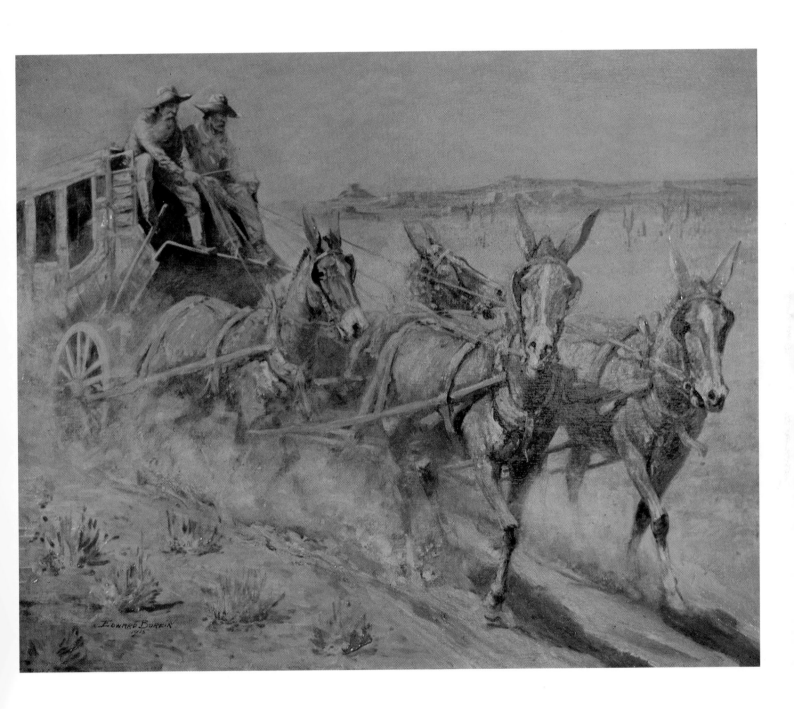

William R. Leigh (1866–1955)

WESTERN SPORTS

In many Indian cultures, skill in horsemanship, physical agility, courage and daring are of great value to the individual and admired by the members of the tribe. W. R. Leigh in *Western Sports* painted a competition in which each contestant, riding at top speed, had to lower himself alongside his horse and, without breaking pace, pick up the marker and cross the finish line. Leigh included in his painting a large crowd of enthusiastic spectators.

In 1906, W. R. Leigh visited the American West for the first time and for many years returned annually to sketch and paint the land and the people. Leigh wrote: "My interest in the West began long before I can remember, I found it all and more than I had dared to expect to hope, and I believe it has called forth the best there is in me." Leigh traveled through Wyoming, the Dakotas, Texas, Arizona, and New Mexico. He lived among the Blackfeet, Sioux, Apache, Navajo, Hopi, and Zuni. He attended religious ceremonies, social festivities, and sport competitions of the tribes he visited. Leigh did not limit his interest to the colorful ceremonies of the Indian tribes, but he also studied the rituals and activities of daily life. Nonetheless, throughout his life he remained an observer and reporter rather than a participant in any phase of Western life.

Trained in the discipline of the Royal Academy at Munich, Leigh was a virtuoso technician and trained observer of detail. Although he was one of the most academically skillful artists to portray the West, some of Leigh's drawings and oil sketches have greater spontaneity and vitality than studio paintings subjected to severe academic discipline. *Western Sports*, an oil that captures the color and excitement of Indian competition, is among Leigh's most successful representations of the Indian world.

Oil. 24 × 18 in.

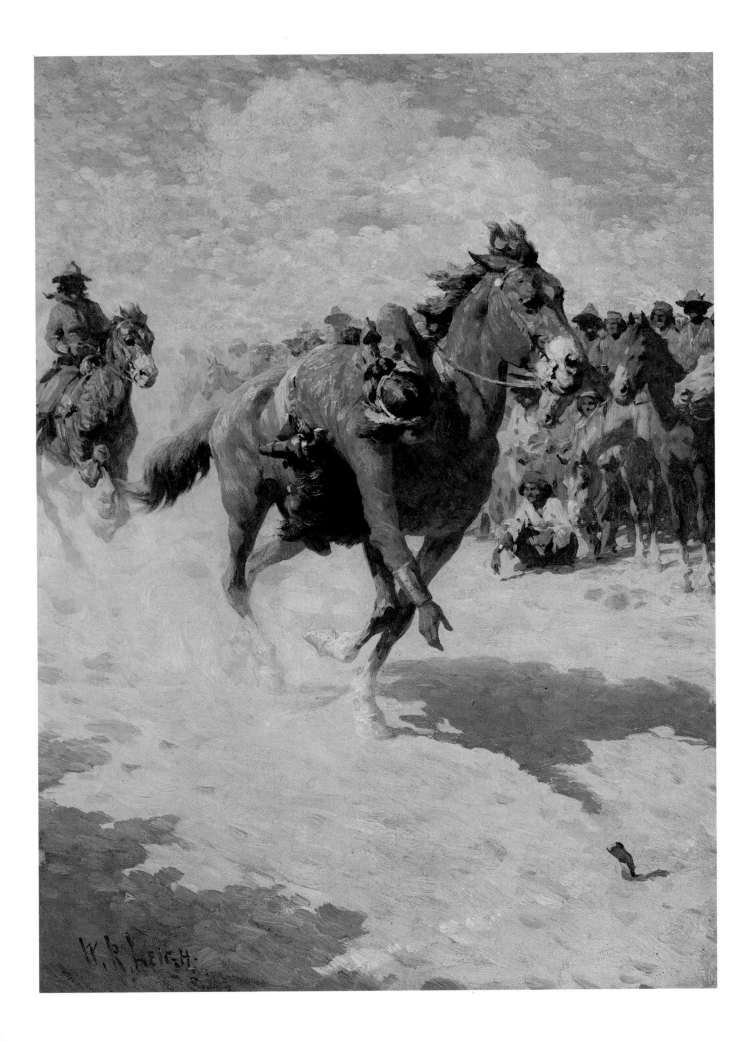

Olaf C. Seltzer (1877–1957)

PROWLERS OF THE PRAIRIE

On HIS TWENTIETH BIRTHDAY Olaf Seltzer was introduced to Charlie Russell. In a newspaper interview published shortly before his death, Seltzer said he had never tried painting in watercolor or oil before meeting Russell. The men became good friends, and Seltzer was a frequent visitor to Russell's studio. Seltzer also joined Russell on wilderness painting excursions. Seltzer, following Russell's example, concentrated on painting Western subjects and scenes. He was particularly interested in subjects about the settlement of the West, and he was confident of his contribution as an artist. In Seltzer's paintings, the atmosphere, colors, and light of Montana clearly show the influence of Russell; however, Seltzer's work has greater linear precision.

When Seltzer arrived in Montana in 1892, the Blackfeet Indians were living on land granted to them by a treaty in 1888. The days of the great buffalo hunts were over, and weekly the Blackfeet visited the Indian Agency for their food rations. But some traces of earlier days remained. The Indians still hunted small game, and several of the old chiefs were still living, but the Montana Territory was in a period of transition, and before long, the government would sell most of the land granted by treaty to the Indians.

Seltzer frequently made sketching trips to Indian country to draw portraits of these Indians, who were living as wards of the government. He also observed the camp life of the defeated people. Since Seltzer realized he had arrived in the West at least a generation too late, he spent hundreds of hours researching Montana's frontier history.

In *Prowlers of the Prairie*, Seltzer recreated the Indian world of the past. Seltzer had a thorough knowledge of the Plains Indian culture, and he was devoted to accuracy of detail. Seltzer's painting celebrates the pride and majesty of the Indians as they hunted the buffalo in the days before the great herds had been destroyed and they were reduced to dependence upon the United States government for the necessities of survival.

Oil. 38 × 47½ in.

110

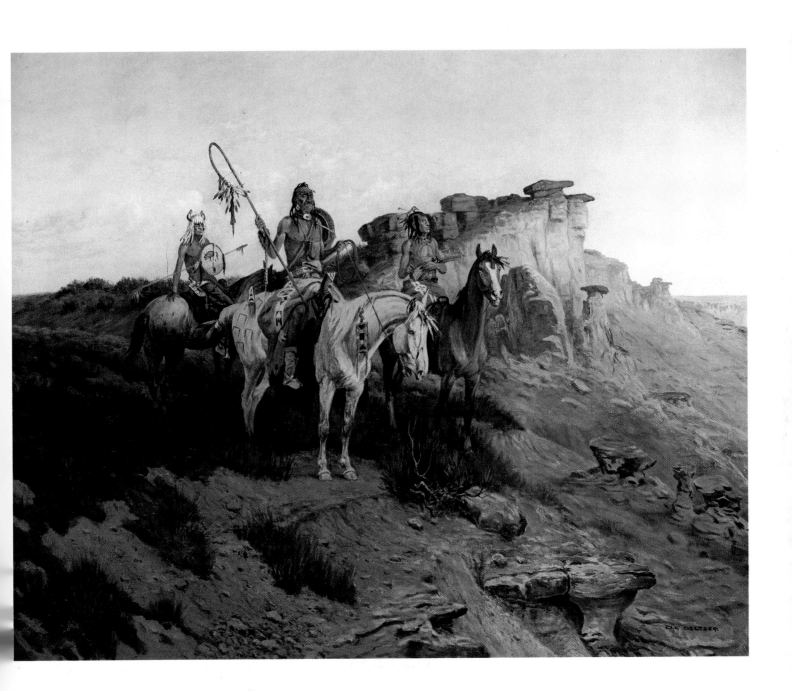

Olaf C. Seltzer (1877–1957)

FREIGHTING FROM FORT BENTON

Although by 1850 the railroad had replaced the Conestoga wagon as the principal means of travel east of the Mississippi, the Conestogas played a vital role as the freighters of the West. The Conestogas were brought by steamboat to the mouth of the Mississippi River, where they were sold to emigrants en route to California and the Northwest and to freighting companies that provided supplies to settlers and miners.

By 1860, freighting was one of the most profitable businesses in the West. Freight from Cincinnati or Pittsburgh was sent by steamer to St. Louis then up the Mississippi River to Fort Benton, Montana. After the discovery of gold in Montana in the 1860s, Fort Benton became the freighting center of the Northwest. Ox teams hauled the wagons carrying supplies from Fort Benton to Virginia City, Helena, and Salt Lake City. The Conestoga ox teams remained one of the principal means of freighting until the end of the Civil War.

Born in Denmark, Olaf C. Seltzer came to the United States in 1892 and worked in Great Falls, Montana, as a machinist for the Great Northern Railway, before devoting himself full time to painting the American West. In 1926 Seltzer went to New York to work on a commission for Dr. Philip Cole. The commission was *Montana in Miniature*, a collection of over one hundred miniature paintings, which illustrated Montana's history. *Freighting from Fort Benton* is part of the series of miniature paintings celebrating Western transportation. Seltzer painted wagon trains, mule trains, stagecoaches, riverboats, express freight lines, early locomotives, and Indian *travois*. Seltzer was interested both in the types of carriers used in the Northwest and in the men who drove freighters. Seltzer was particularly interested in the freighting industry during the gold-rush period in Montana.

Oil. 4 × 5¾ in.

112

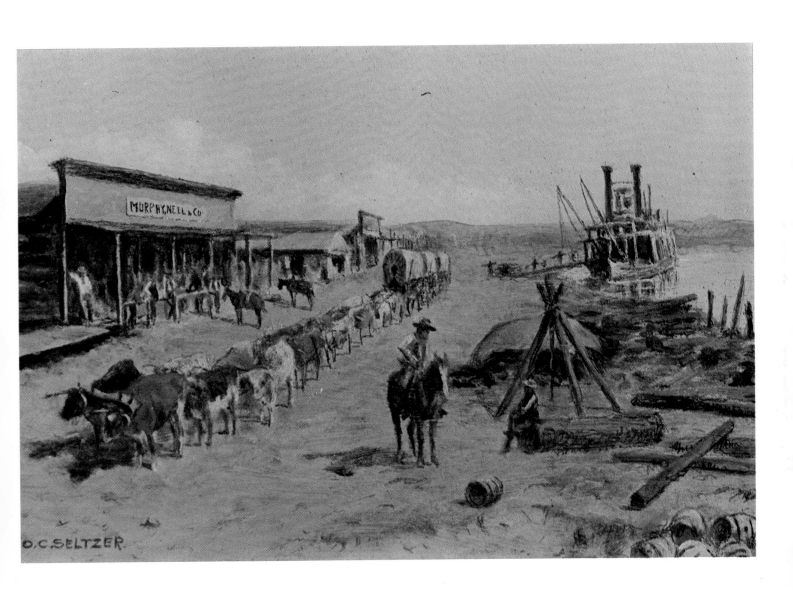

Frank Tenney Johnson (1874–1939)

THE OVERLAND TRAIL (1926)

The Overland Trail from Independence, Missouri, to the Pacific Ocean was charted and mapped by John C. Fremont in the early 1840s. After Fremont's report was published in 1843, the Overland Trail became the major wagon-train route to the West. During the 1850s the California Trail, a cut branching to the south, became an alternate route to the Pacific coast. Many of those bound for the California gold rush followed the Overland Trail—via the North Platte Valley—and the South Pass of the Rocky Mountains. Then they took the California Trail across the Great Basin and the Sierra Mountains.

Buffalo stampedes, prairie storms, and Indian attacks were among the dangers of the long journey. Many of those traveling West joined a wagon train and depended on the knowledge and experience of the wagon master for their safety. Many emigrants heading West preferred to use a team of six or eight oxen, for oxen could live off all but completely barren land. And if the food supply ran out or if an animal was injured, an ox could be slaughtered and eaten without seriously damaging the power source of their transportation. The ox-drawn wagon covered an average of twelve to fifteen miles a day.

Frank Tenney Johnson was born on a pioneer farm on the prairie of western Iowa. Johnson recalled: "Day after day I watched the prairie schooners pass on their way to Council Bluffs and across the Missouri to the West, where the land of opportunity ever beckoned. It was only natural that I should look forward with longing to the day when I too might go West and learn to paint what was there." Johnson's dream was realized when *Field and Stream Magazine* commissioned him to travel to the West to gather material for a series of illustrations. Johnson traveled to Colorado, to Wyoming, and throughout the Southwest. He took hundreds of photographs with his Kodak, and he sketched the scenery and people of each area. Johnson was fascinated by the luminous glow and shadows cast by the moon on the canyons and cliffs. For the rest of his career, he tried to capture on canvas the special beauty of moonlight in the West.

Oil. 28 × 36 in.

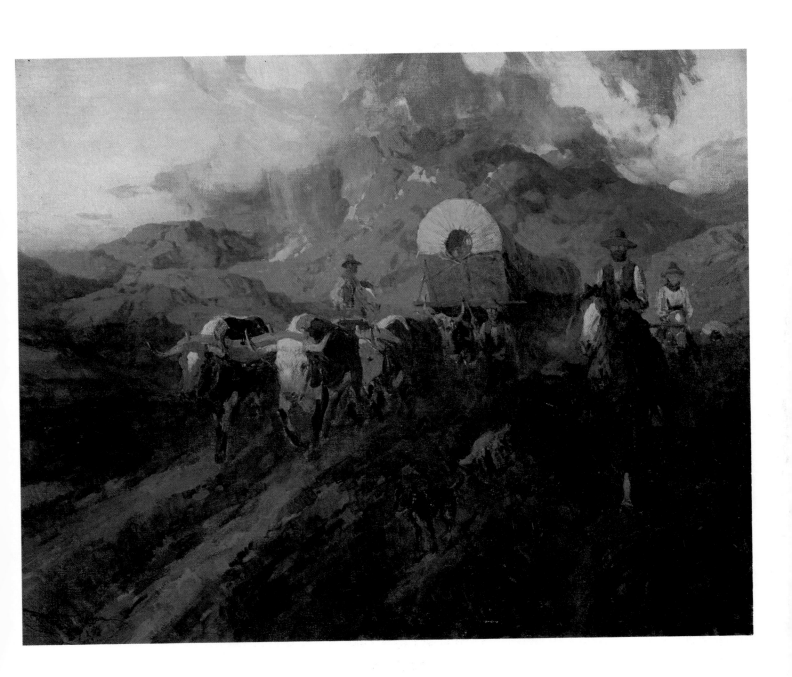

Frank Tenney Johnson (1874–1939)

CALIFORNIA OR OREGON (1926)

In 1848 Oregon was formally organized as Capital Territory, and in 1859 it was admitted to the Union. After the discovery of gold in Sutter's Fort, California, in 1848, thousands of prospectors and settlers chose California, rather than Oregon, as their destination in the West. Oregon gained many new settlers, however, when Congress passed the Capital Donation Land Act, allotting 320 acres of public land free to every man who settled in Oregon before December 1, 1850. An additional 320 acres were allotted for the man's wife, a provision that inspired the unmarried Oregon-bound settler with a sense of great urgency in his search for a bride. In 1853 Washington Territory was created from the region of Oregon Territory north of the Columbia River. After 1853 Congress reduced the acreage allowance from 320 to 160 acres. The settlers had to remain on their land claims for a minimum of four years in order to acquire permanent title.

By the 1840s and 1850s, thousands of settlers traveled west to California and Oregon. The safest way to make the hazardous journey across the plains and mountains was to join a wagon train under the supervision of an experienced wagon master. Thousands of gold seekers and settlers traveled West in ox-drawn covered wagons, which were part of the long wagon trains.

Not all travelers, however, enjoyed the minimal comforts and limited safety that joining a wagon train ensured. The promise of free land or gold inspired thousands to brave the hardships and dangers of solitary travel across the West. Many, unable to afford the luxury of an ox team, were forced to depend on a team of hearty mules. The mule was the most popular pack animal in the West, and on the Santa Fe trail covered wagons pulled by mule or oxen were the principal vehicles used for freighting.

Oregon or California—it was a hard and interesting choice. There was the promise of instant wealth if one were lucky enough to find gold in California, or the promise of a secure future as a landowner if one followed the provisions of the government's land allowance in Oregon. The West was the land of the future, and the choice was up to the individual.

Oil. 30 × 40 in.

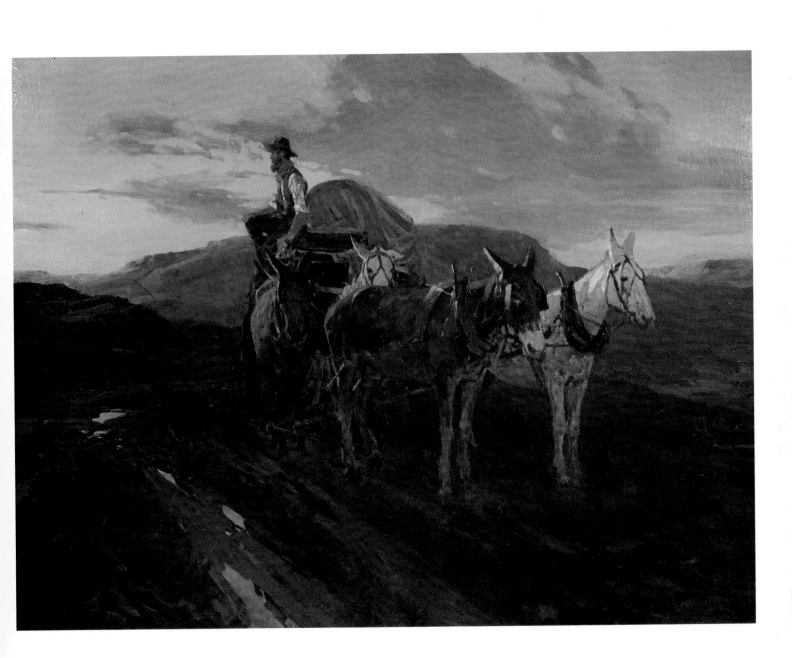

William Gollings (1878–1932)

INCIDENT IN CAMP

Bill Gollings loved the life of the ranch and the life of the range. He loved the streets and saloons of the cattle towns of the West. The paintings and the life of Bill Gollings are typical of a generation of artists who devoted their life and art to the romance of the American cowboy and the American West. From childhood Gollings idolized Frederic Remington and the life he depicted, and determined to dedicate his life and work to recapturing the excitement, glamour, and zest of the world Remington had portrayed. Gollings loved working as a ranch hand and cowboy and painting the incidents of ranch life. He enjoyed traveling across the land of the Indians and painting scenes of the Indian world.

Although Gollings was born in a mining camp in Pierce City, Idaho, when he was twelve, his family moved to Chicago. There he completed his education through eighth grade. In 1896 he traveled West by train across South Dakota and went to work as a cowboy for a large cattle company. When he was twenty-five years old, Gollings ordered his first painting materials from a Montgomery Ward catalogue and tried his hand as an artist. His brother DeWitt, a rancher in Wyoming, was so impressed by these first efforts that he arranged to have his brother's paintings exhibited in a furniture store in Sheridan. The furniture dealer sent the young Gollings a check for $50, which served as fare to the West. Gollings settled down to a life on his brother's ranch, which included riding line on the Cheyenne Reservation, breaking horses, and painting. His romance with the West was disrupted when he won a scholarship to the Chicago Academy of Fine Arts. But after two months he traded a painting for a railroad ticket and returned to Wyoming.

In 1909 Gollings decided to give up cowboy life and devote full time to painting but could not resist periodically returning to work as a ranch hand or riding on a roundup. Throughout his life Gollings was a working cowboy who painted the life and world he loved—the West of the cowboy and the Indian, the horses and the cattle, and the ranch and the range.

Oil. 25 × 42 in.

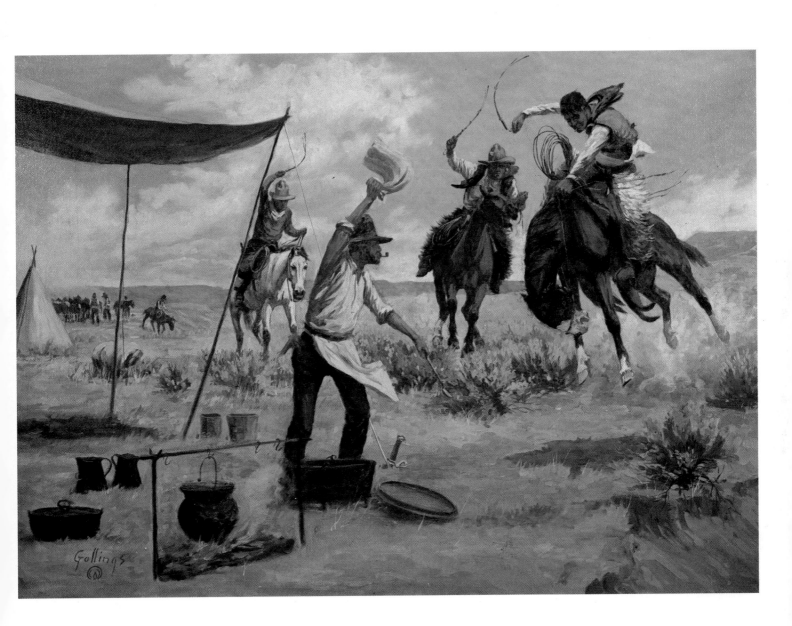

Howard Pyle (1853–1911)

GEORGE ROGERS CLARK ON
HIS WAY TO KASKASKIA

IN 1778 GEORGE ROGERS CLARK, brother of the explorer William Clark, helped open the way to the American West by securing the Northwest Territory, the land which is now Ohio, Michigan, Indiana, Illinois, Wisconsin, and part of Minnesota. Born on a Virginia plantation, Clark worked as a surveyor in the Kentucky country and took part in Lord Dunmore's war against the Indians. Although only twenty-five years old when the American Revolution broke out, Clark realized that the British were inciting the Indians to attack the American settlers and that victory in the country west of the Allegheny Mountains depended on winning the support of the Indians. Clark enlisted troops and, with less than two hundred men, captured three important British frontier posts—Kaskaskia and Cahokia, on the Mississippi River near St. Louis, and Vincennes, on the Wabash River. These victories over the British helped win the friendship of the French settlers and the neighboring Indians. In 1781 the Treaty of Paris ceded to the United States the land Clark had won.

Howard Pyle, the father of American illustration, paid tribute to George Rogers Clark by portraying the moment when Clark, with his small group of followers, crossed the Ohio River on their way west. Born in Wilmington, Delaware, Pyle was a gifted writer, artist, and teacher, and he was the founder of the Brandywine school of illustration. During his career, Pyle worked as an artist for the leading periodicals of the day and won recognition for illustrations of literary classics and juvenile fiction and histories. Pyle inspired his students with an idealism and sense of mission in artistic creation. Dissatisfied with the limitations of formal art education of his day, he formed his own teaching studio in Chadds Ford, Pennsylvania. The list of Pyle's students includes many of America's most important illustrators: N.C. Wyeth, Frank Schoonover, Maxfield Parrish, Jessie Wilcox Smith, and Harvey Dunn.

Oil. 30 × 42 in.

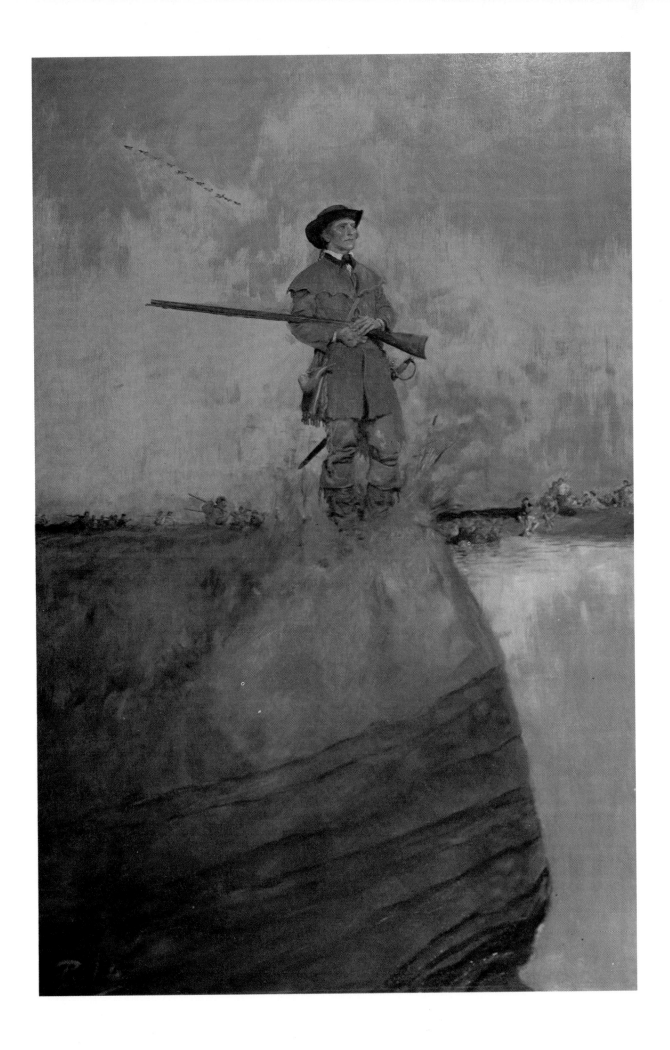

N. C. Wyeth (1882–1945)

THE JAMES GANG

Jesse James and his brother Frank were born and reared as farm boys in Clay County, Missouri. During the Civil War they joined the Confederate guerrillas, for they believed the family had been mistreated by the Unionists. Although Missouri had voted to stay in the Union, the people were bitterly divided in sentiment, and several battles were fought between Union and Confederate forces in Missouri. After the war, still convinced that they had been victimized, the James brothers turned outlaw and formed a band that specialized in train and bank robbery. They managed to evade the law from 1866 until 1882, when two members of their own band, who had turned bounty hunters for the $10,000 reward, shot Jesse in the back. Frank surrendered the following year. Stories, both fact and fiction, of the pursuit of these outlaws—by the Pinkerton Agency, sheriffs, and marshalls—and of the daring exploits of the James Gang spread across the country, and the James brothers became a legend of the West.

Banks were often thought of as institutions of the rich—and capable of unfair treatment of the common man. The bank robbers never aroused public hatred, as did the common horse thief or the cattle rustler. Because of the Westerners' dependence on the horse, the horse thief was judged to be worse than a murderer.

In American folklore both the Western outlaw and the lawman are heroes. The outlaw confirms the very code he violates, for there is no question about the validity of his crime. Both lawman and outlaw defend or violate the same legal and moral codes and there is never a question as to the outcome of a career of crime or the ultimate punishment of the outlaw because of the strength and solidarity of frontier law.

N. C. Wyeth is best known for his illustrations of children's classics, many of which were romantic adventures of the old West. He was the founder of a dynasty of artists, which includes his son Andrew and his grandson James.

Oil. 25 × 42 in.

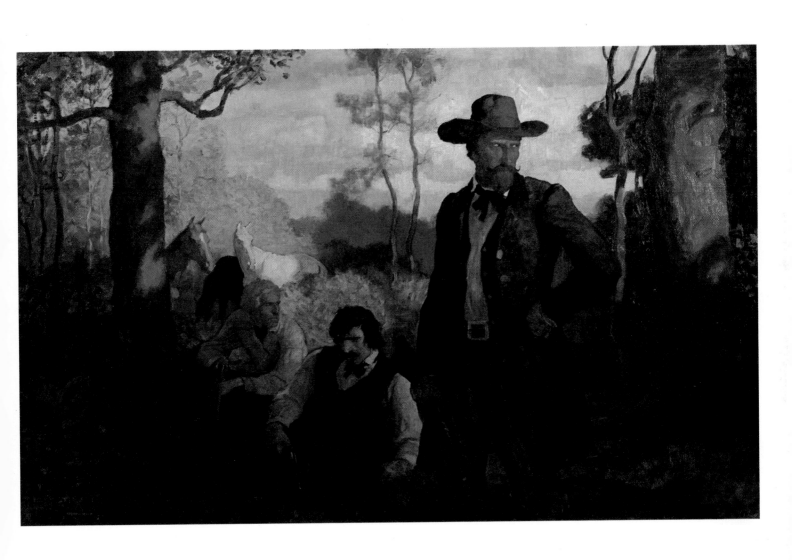

Thomas Eakins (1844–1916)

FRANK HAMILTON CUSHING

IN 1879 FRANK HAMILTON CUSHING, a young anthropologist and ethnologist, arrived at the villages of Zuni. He was interested in studying life at Zuni as an example of a surviving primitive culture. Cushing had great respect and empathy for the Zuni people; however, his scientific zeal led him to intrude on some of the most sacred ceremonies and rituals of the Zuni. Several of the Zuni resented this violation of the sanctity of their ceremonial rites in the name of investigative science. In fact, at one time Cushing's life was threatened. But most Zuni were friendly to Cushing, and for five years he lived in peace, studying all aspects of Zuni life and religion. The Zuni ultimately bestowed on Cushing membership in the War Society. On his return to Washington, Cushing published several studies with detailed descriptions of Zuni ceremonial, social, and daily life. Cushing's book, *My Life at Zuni*, is a classic.

Thomas Eakins, portrait and genre painter, was the leader of American realist painting in the late nineteenth century. Eakins sought truth rather than beauty or sentiment in his work. Eakins' goal was to create an objective record of life in the world around him. In his pursuit of artistic truth, he taught anatomy and experimented with serial photography of humans and other animals in motion. Eakins' only visit to the American West was his trip to a ranch in the Dakota Badlands during the summer of 1887.

Eakins painted several of the most important American realist portraits. He painted many of his subjects engaged in their professions and surrounded by the instruments necessary for their work. Eakins' portrait of Cushing was done in his Philadelphia studio in about 1895. Eakins painted him dressed as a Priest of the Bow, a sacred Zuni fraternity to which Cushing belonged. Cushing holds two feathered fetishes and is surrounded by artifacts of Indian life. Eakins, with Cushing's help, converted his studio into a replica of a room at the Zuni Pueblo. The walls and floors were earth, and a ladder provided the entrance and exit.

Eakins tried to achieve in his portraits a sense of the personality and mood of his subject. Although Cushing was only thirty-seven years old when he posed for Eakins, his health was failing (Cushing died five years later), and the majority of his life's work had been completed. Eakins painted Cushing lost in contemplation—a melancholy, introspective man.

Oil. 47 × 45 in.

Ernest L. Blumenschein (1874–1960)

MOON, MORNING STAR, EVENING STAR

MOON, MORNING STAR, EVENING STAR is a symphonic tribute to Indian spirituality. Through the rhythms of the vibrant forms, the harmonies of the rich autumn colors, and the melody of the celebration of the harvest ceremonial, Blumenschein expresses the power, beauty, and mysticism of the Pueblo religion. This painting depicts a harvest ritual, a ceremony of thanksgiving and prayer for the continued beneficence of the celestial powers that determine the well-being and survival of people on Earth.

A priest stands in the center of the plaza. At his feet lie the symbols of the harvest—corn, fruit, melons, and squash—staples that will feed the community during the long winter. Animal dancers, wearing the heads and skins of elk, cougar, buffalo, and hare, form a circle around the priest. The dancers bend forward as they lean on sticks, their stance symbolic of the four-footed animals. Surrounding the circle of dancers are hunters carrying bows and arrows. In the foreground the Pueblo singers chant the ancient prayers of the Taos people.

Grouped around the animals and hunters and crowded on the adobe roof tops are the Taos people, who attend the ceremony and add their prayers to those of the ceremonial dancers and singers. These clusters of Indians echo the form of the distant mountains, symbolizing the unity of the Indian people and their environment. They are wrapped in blankets in the tradition of the Taos Indians. In the distance are the snowy peaks of the Sangre de Cristo Mountains, an ever-present reminder of the onset of winter. A dark cloud, a source of life-giving rain for the crops, moves toward the mountains. Stylized images of the moon and stars appear high in the center of the painting, symbols of the transcendent spirituality of the sacred nocturnal ceremony.

Ernest Blumenschein, with Bert Phillips, founded the Taos art colony in 1898. Throughout his long career in New Mexico, Blumenschein devoted his creative abilities to capturing the spiritual essence and the physical likeness of the Indian and Spanish people in the area.

Oil. 50¼ × 40¼ in.

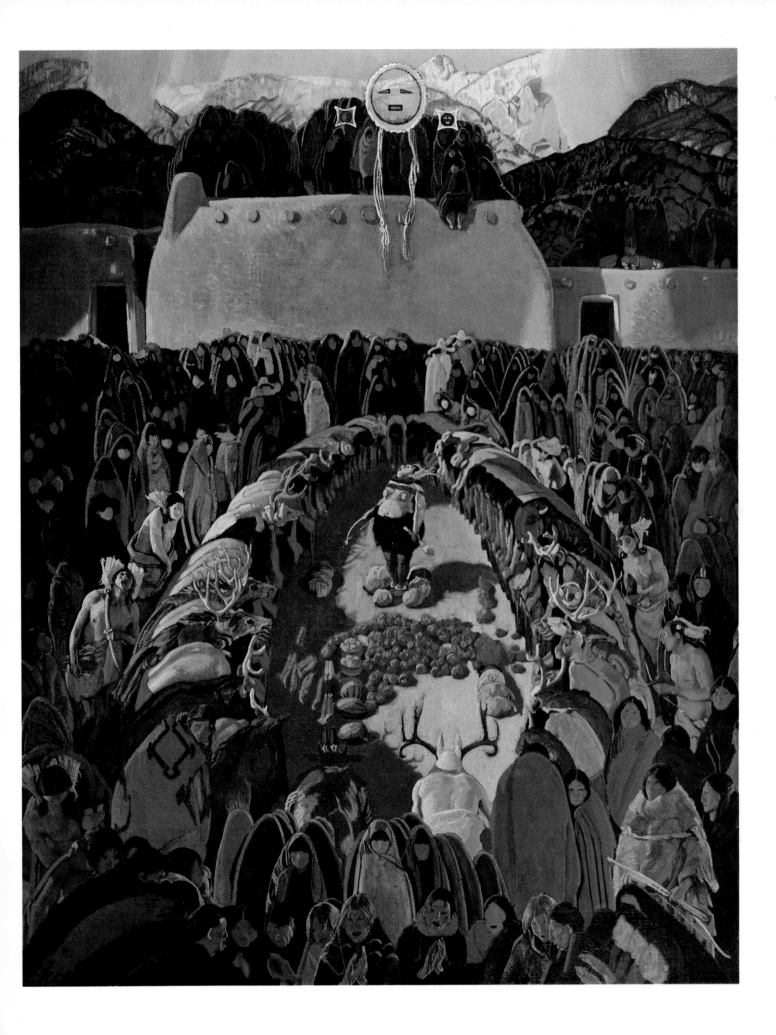

Ernest L. Blumenschein (1874–1960)

SUPERSTITION

THERE IS AN OLD SAYING THAT superstition is the other man's religion. Ernest L. Blumenschein examines in *Superstition* the ideological conflict faced by the Pueblo Indians after the Christian missionaries arrived in the Southwest. For the Indians raised in the religion of their ancestors, Christianity was the white man's superstition. To the missionaires and early settlers who believed they were bringing the gift of civilization and salvation to the heathens, the beliefs and rituals of the Indians were looked upon as pagan superstition. The twin-mouthed wedding vase symbolizes the alternatives of the ancient religion of the Pueblo Indians and the doctrines taught by the Christian missionaries.

Blumenschein has included in his composition the icons of the two cosmologies—the masked image, a symbol of the Pueblo spiritual world, part of the divine order of the universe; and the crucifix, a symbol of redemption through Christ. Behind the Indian are rocks incised with the petroglyphs of his ancestors, documenting the past history of the Indian people. By the time Blumenschein reached Taos, the Indians had officially accepted the Christian church, but they had also maintained most of their fundamental beliefs, as well as their rituals and ceremonies.

Blumenschein had great admiration and respect for the beliefs and traditions of the Pueblo Indians. He realized that the rituals for rain, fertility, germination, and regeneration were of primary importance to a civilization dependent on the rain and snow for an abundant harvest. Blumenschein understood that most of the doctrines of Christianity were foreign to the Pueblo Indians and had little relation to their way of life.

For over two hundred years Taos had been the focal point of religious and governmental controversy. *Superstition* was painted in 1921, the year in which the Indian commissioner and his assistant invaded the Taos council, accused the Taos Indians of being "half animals" and "pagan worshippers," and outlawed all Indian dances and ceremonials except those authorized and approved by the Bureau of Indian Affairs. Blumenschein's painting dramatizes the dilemma of the Indians struggling to maintain their identity in a transitional world.

Oil. 47 × 45 in.

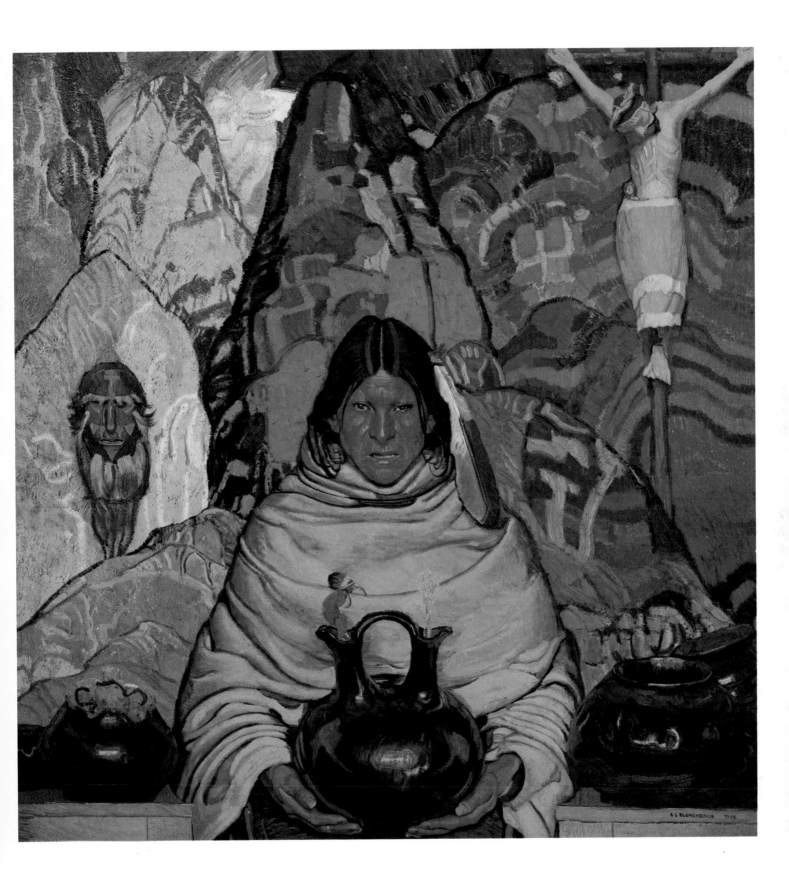

Joseph Henry Sharp (1859–1953)

THE POTTERY DECORATORS

JOSEPH SHARP IN *THE POTTERY DECORATORS* portrays the beauty and harmony of life in the Pueblo world. The Pueblo potters have created objects of utility and beauty while working within the tranquillity of the adobe interior. These women embody the spirit of creativity in Indian life. The Pueblo potters enjoy a rich heritage in ceramics that has been passed down through the centuries, for pottery is one of the most important of the Southwest Indian craft arts. A fine grade of ceramics was produced in the Southwest by the Hohokam culture by 2000 B.C. Throughout the Southwest there are abundant deposits of clay, and through the centuries the Indian people have produced earthenware vessels for their own use and for trade. Traditionally, the women have been the potters among the Pueblo Indians.

Joseph Sharp was the first of the pioneer artists of Taos to visit the Pueblo and the New Mexican village. In 1893 he spent the summer working on a magazine assignment, and he recognized the rich artistic potential of living in New Mexico and painting the Pueblo world. Although Sharp realized that Taos held a wealth of unexplored Indian subject matter, he did not establish a studio in Taos until 1909, when he purchased a chapel of the Penitentes (a Spanish religious sect).

Sharp was drawn to the land and the brilliant sunlight of New Mexico; however, his primary interest in New Mexico was the opportunity to paint the Pueblo Indians. The ancestors of the Indians living in the Rio Grande pueblos lived in the Southwest over a thousand years ago. The Pueblo Indians had endeavored to preserve their cultural integrity despite over three hundred years of Spanish, and American domination. Sharp, often termed "the antropologist," was an accurate observer of Pueblo life. He reported faithfully the customs, rituals, and appearance of the Pueblo people. His paintings are characterized by their authenticity in representing household interiors, clothing, and crafts of the Indian people.

Oil. 24⅛ × 38⅛ in.

130

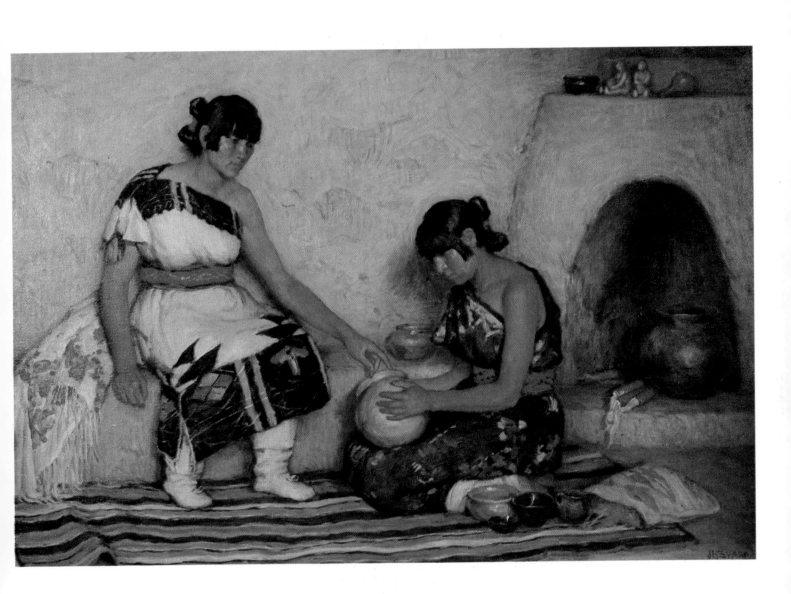

Joseph Henry Sharp (1859–1953)

STORY OF THE WAR ROBE

In 1899 Joseph Henry Sharp spent the first of many winters in Montana painting the ceremonies and daily routines of the Crow, Blackfeet, and Sioux Indians. He also completed portraits of many of the Indian people, including tribal leaders and several braves reported to have fought in the battle of Little Big Horn in 1876. Sharp's first studio, Prairie Dog, was converted from a sheep-and-cattle herder's commissary wagon and could be hauled to different locations. A sheet of mica served as a skylight. Sharp chose for the location of his studio a spot on the Custer Battlefield near the confluence of the Little Big Horn and the Big Horn rivers. Following the installation of several of Sharp's paintings in the Smithsonian Institution, Theodore Roosevelt directed the Indian Commission to build and furnish a small log cabin and studio for Sharp. It was to be near the Custer Battlefield and next to the Crow Agency.

Sharp's paintings of the Montana Indians are documents of a culture in transition, for the Crow and Sioux were among the last tribes to retain the traditions of the Plains Indians. In *Story of the War Robe* an elder of the tribe retells the story of a past moment of glory. Tales of battles were frequently painted on animal skins, and the young Crow look wistfully at the hide painting as they contemplate a life of independent action, which they will never experience. They sit motionless, in contrast to the mounted warriors painted on the robe.

By the turn of the century, the Crow had been defeated by the United States Army and confined to a reservation. During these first years of reservation life, the Crow tried to retain their cultural identity by observing as many of their ceremonies and rituals as possible. Their oral tradition enabled them to preserve the history of happier and more prosperous days—days of independence and freedom. Sharp, like the Indian elders, was motivated by a sense of mission: "In past years I have seen so many things and have made studies that probably no other living artist ever saw . . . if I do not paint them no one ever will . . ."

Oil. 30¼ × 36⅛ in.

132

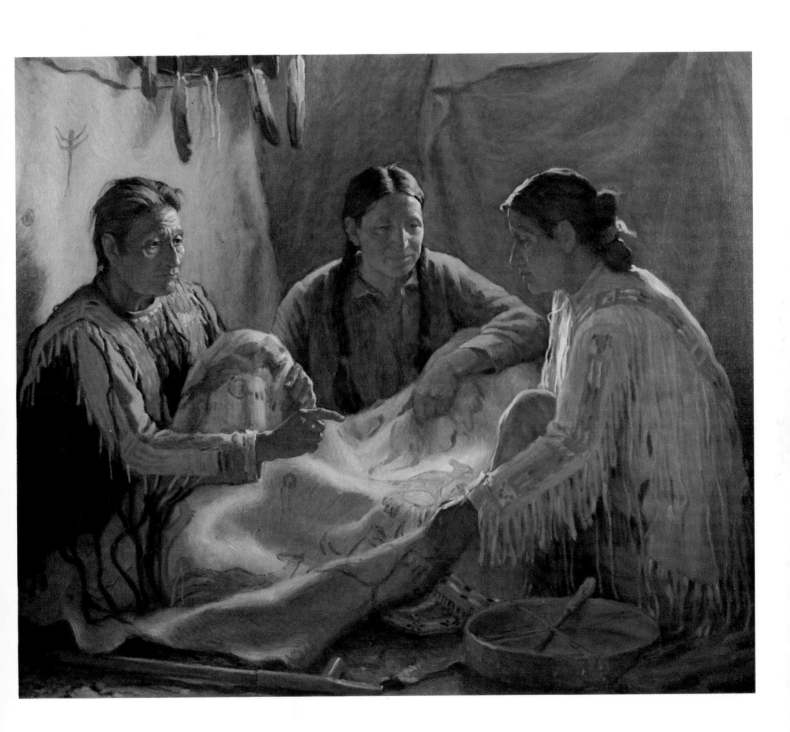

Oscar E. Berninghaus (1874–1952)

THRESHING TIME (1944)

OSCAR E. BERNINGHAUS first visited Taos in the summer of 1899. Berninghaus, a commercial artist from St. Louis, was traveling on the Denver and Rio Grande Western Railroad on a sketching tour of Colorado, part of a commission to illustrate pamphlets describing the scenic wonders along the route. Berninghaus took a tour on the Chili Line, the narrow gauge spur of the D. & R.G.W., which ran from Alamosa, Colorado, through the San Juan Mountains to northern New Mexico and on to Santa Fe. From Santa Fe, Berninghaus journeyed to Taos on the old mail stage. Berninghaus described his first view of Taos: "The trip took ten hours, and the wild expanse of mountain and desert, the curious coyotes and prong-horned antelopes that trotted along behind the coach or stood close-by while the conveyance passed, delighted me as did the little adobe town and the massive piles of the pueblo."

The life of the Indians of the Taos Pueblo was focused on the demands of a farming culture. Historically, the Taos economy was basically subsistence agriculture, supplemented by gathering wild crops and hunting. During the early years of the twentieth century, the principal crops of the Taos Indians were wheat and corn. They also grew squash, beans, and melons. With the exception of wheat, which was introduced to the Indians by the Spanish, these were the crops raised through the centuries by the ancestors of those living at the Pueblo.

By 1900 the American plow was in common use. Initially these plows were pulled by both oxen and horses, but by the 1920s horses alone were used. The Indians cut the wheat with sickles, then stacked the wheat in a fenced area with a hard adobe floor. The wheat was threshed by the trampling hoofs of horses and, occasionally, by goats. A mounted Indian herded the horses that galloped about the stack, trampling the wheat. Stalks of wheat from the stack were thrown onto the track until all the wheat was threshed.

The 1920s were years of agricultural crisis in Taos, for economic hardship and revolutionary advances in the technology of transportation ended large-scale wheat farming in the area. Berninghaus painted *Threshing Time* in 1944, when these harvest rituals were memories from the past.

Oil. 29½ × 30 in.

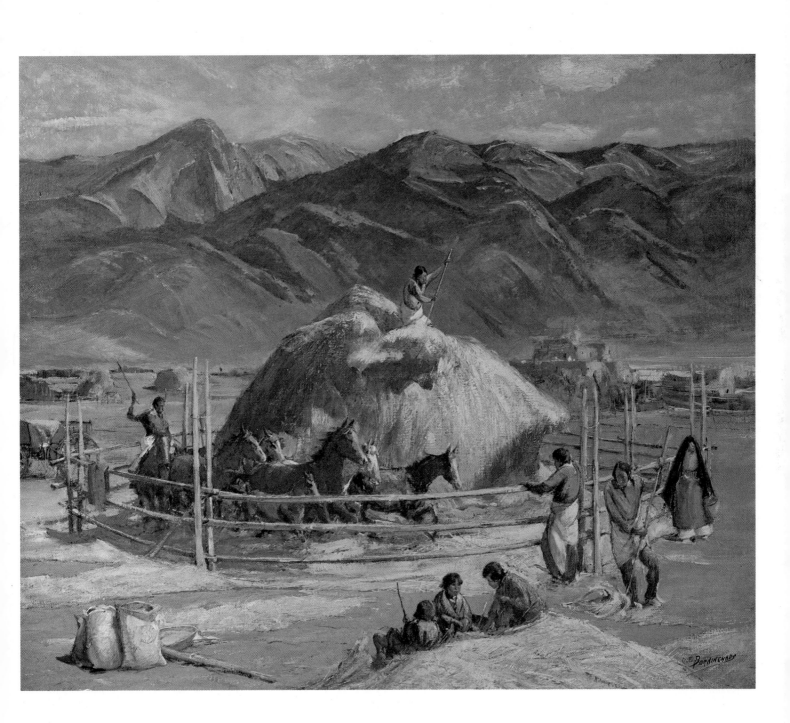

Oscar E. Berninghaus (1874–1952)

TOO OLD FOR THE RABBIT HUNT

THE RABBIT HUNT FOR THE PUEBLO INDIANS is a rite of coming of age, part of the ritual initiation from boyhood to manhood. The catching of a first jackrabbit is an event to be remembered and celebrated. The rabbit hunt is often a formal ritual. The hunters, aided by dogs, form a large circle, often over a mile in diameter, and close in, beating the bushes and yelling as the rabbits run toward the center. When a rabbit breaks through the line, a hunter chases it and tries to kill it by striking it with a curved throwing stick. Some Indians hunt on foot, some on horseback, and some on burros. Before the hunt there is a ritual blessing to bring luck to the hunters. After the hunt there are festivities and feasting. The Indians give thanks for their good fortune in the hunt, and they thank the spirits of the animals for providing food for the Indian people. They also pray for living creatures to multiply on earth. By the twentieth century, rabbits were hunted with rifles as well as with throwing sticks.

Oscar Berninghaus' paintings of the Indians of Taos are neither stereotypes of picturesque aborigines or romantic portraits of the noble red man. That is because Berninghaus had great insight into the problems of people living in a transitional world. The Pueblo Indians of the Taos pueblo lived side by side with two distinctly different cultures—the Spanish-Mexican and the Anglo. These cultures had had a profound effect on the economic, religious, and social life of the Pueblo people. By 1927, the year in which Berninghaus painted *Too Old for the Rabbit Hunt*, the New Mexican village of Taos had grown in population; the lands immediately surrounding the Pueblo were no longer the open hunting fields of fifty years earlier, and hunting was no longer the only means of obtaining meat. Taos in the late 1920s was the world of the Model T, and Indians were employed as household servants. Denim work pants were standard Indian clothing, and their sacred dances were becoming tourist attractions.

The Indian in Berninghaus' painting is too old for the hunt, not only because of his chronological age, which has brought the lessening of physical powers, but because the passage of time has brought him into a changed world. As he dreams of the past, he remembers both the rituals of his youth and a world in which these rituals were of primary importance to the economic and spiritual well-being of his people.

Oil. 35 × 40 in.

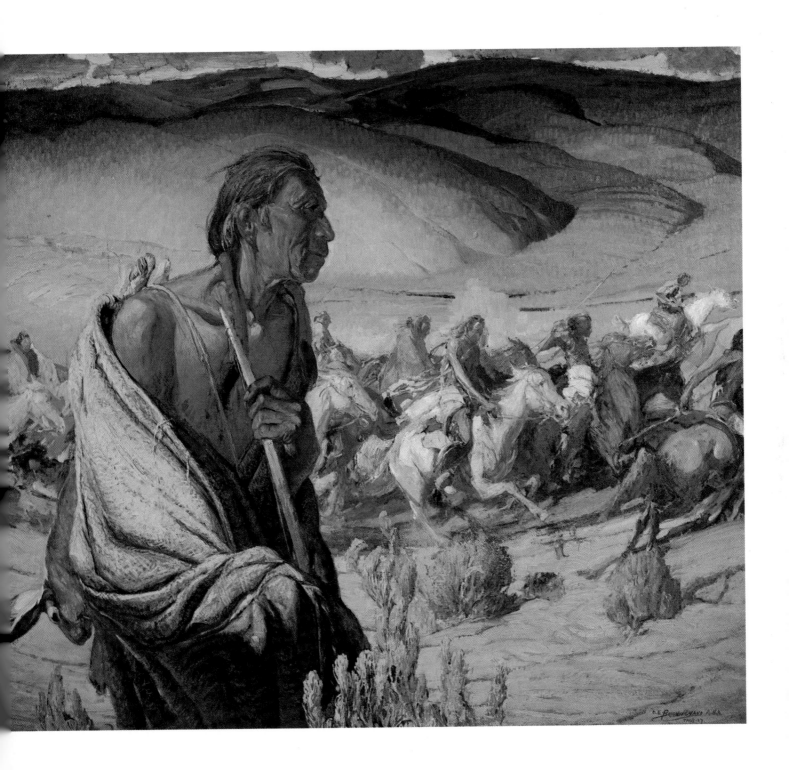

Bert Phillips (1868–1956)

A PUEBLO HUNTER

A Pueblo Hunter by Bert Phillips is a romantic portrait of a traditional Indian activity that recaptures the tranquillity of the Indian world. The hunter, in search of food rather than sport, is not an intruder; he is part of the harmonious mountain and forest landscape. Phillips, shocked by the destruction caused by unheeded forest fires and by the thoughtless cutting of forest timber, was active in establishing the Kit Carson National Forest. He was also the first ranger of the Taos Forest Preserve.

Phillips was the first of the founders of the Taos Society of Artists to establish a permanent residence in the New Mexican village. From the time of his arrival in New Mexico in 1898 until his death in 1956, Phillips enjoyed the friendship and confidence of the Pueblo people he painted. One of his first trials for acceptance among the Taos Indians was a foot race against the best young Indian runners. As a boy, Phillips had practiced sprinting, a skill that enabled him to win the race and the admiration of the Indians.

Phillips devoted his life to portraying the beauty he found in the land and people of New Mexico. Phillips was a true romantic, inspired by the natural wonders of New Mexico—the catcus-covered high desert, the Rio Grande canyon, the silhouette of the Sangre de Christo Mountains, and the aspen forests. Phillips' greatest source of inspiration were the Indian people of Taos. He felt a natural bond to a people who believed that the key to universal progress was maintaining harmony between man and nature. Phillips loved the Indian people, for he shared their desire to express beauty in every aspect of life. Phillips had a deep appreciation of Indian art, as expressed in craft designs and in music. Throughout his life Phillips found beauty to be the greatest source of creativity.

Oil. 40 × 26 in.

138

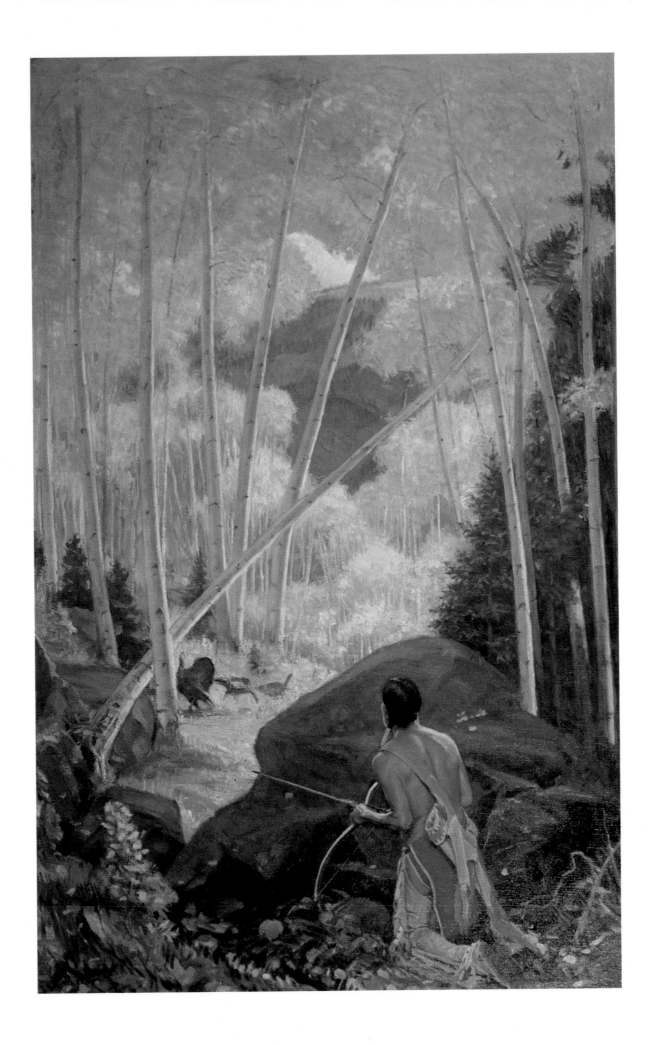

Eanger Irving Couse (1866–1936)

THE ARROW MAKER

In 1901 Eanger Irving Couse arrived in Taos to paint the Indians of the area. Several years earlier Couse had painted the Klikitat, Vahue, and Umatilla Indians in Oregon, but the people of these tribes were hesitant to pose. They were frightened by the superstition that part of their soul would remain with the painted image and ultimately cause their deaths. While working in Paris, Couse had met with Joseph Sharp, who had praised the beauty of the Taos people and had assured Couse of the Indians' willingness to pose for the artist. The Taos people and their routines of life at the Pueblos satisfied all of Couse's artistic requirements and desires.

The Arrow Maker represents the change at the turn of the century in the attitude of the American people toward the Indian. During the nineteenth century the Indian was stereotyped as a savage, a threat to the progress of civilization. Magazines and melodramas advertised horrors and massacres by the wild men of the West. A contrasting image of the Indian, which coexisted with the view of the Indian as enemy, was the image of the Indian as a child of nature. By 1900, however, the Indians were no longer a threat to the settlement of the West, for the era of Indian reprisals and uprisings was over. The defeated Indian became the object of sympathy, and the Indian was sentimentalized as the vanishing American.

Couse and the artists who came to Taos found an Indian culture relatively undisturbed by the events of the nineteenth century. In contrast to the stereotypes of hostile or vanquished Indians, the Taos Indians lived as they had for centuries, following many of the daily rituals of life and the ceremonies of their ancestors. *The Arrow Maker* glorifies an everyday activity in the life of a Pueblo Indian. His arrow will be used for the hunt, not for the battle. Here is the beauty and poetry of life lived in harmony with the laws of nature. Couse was truly a romantic, and his paintings are sincere idealizations of the beauty and equanimity of the Indian people. Couse's Indian is a symbol of tranquillity—life as it was lived in a preindustrial age. For Couse, even the shade of the Taos Indian's skin was a fulfillment of his dream of the perfect red man. Time and again he painted the Indian before a fire, his skin glowing in the reflected light.

Oil. 24 × 29¼ in.

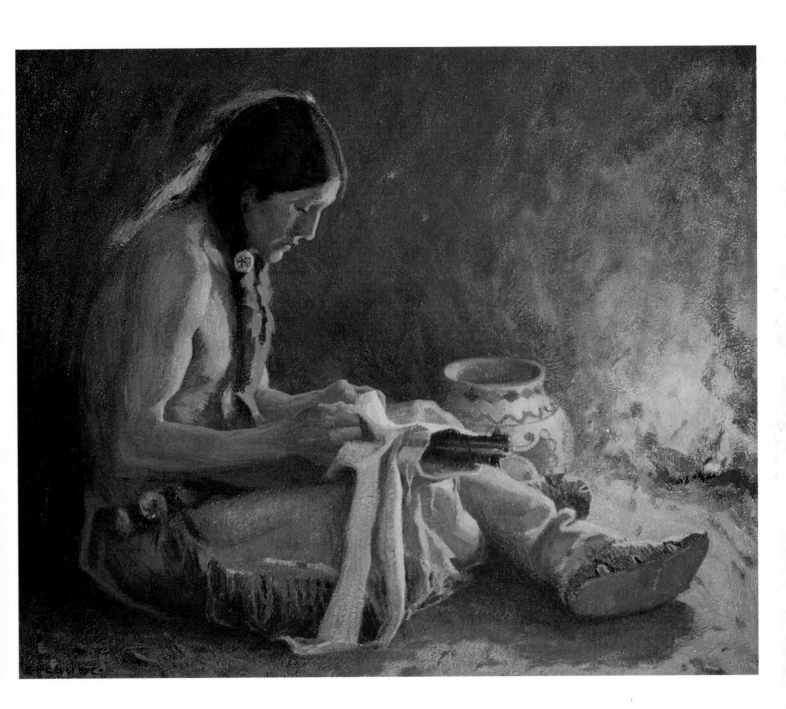

W. Herbert Dunton (1878–1936)

CROW OUTLIER

Dᴜʀɪɴɢ ᴛʜᴇ ɴɪɴᴇᴛᴇᴇɴᴛʜ ᴄᴇɴᴛᴜʀʏ *outlier* was the term used in the frontier regions to describe an individual who remained apart from the masses—a man who lived and worked alone as a solitary bushwhacker or marauder. In *Crow Outlier,* the Crow brave rides alone, isolated from both his own people and from the white man. Dunton's work is a nostalgic one, filled with longing for a world of the past of which he had had only a limited glimpse. Dunton traveled in Montana, the home of the Crow, six years after the last major episode of the conflict between the Indians and the United States government—the massacre of the Sioux at Wounded Knee in 1890. Although the Crow were confined to a reservation in Montana, the eighteen-year-old artist could visualize the Indians enjoying the freedom of the past. The land had been transformed into range country, but occasionally Dunton had the opportunity to study the vestiges of Indian life on the plains.

Dunton periodically worked as a cowboy, and the body of his work extols the world of the cowboy and the romance of the cattle industry in the days before the barbed wire of the farmers ended the open range. He recognized that the cowboy riding on the open range would soon be relegated to romances and history books, as had been the Indian riding across the free plains: "The West has passed—more's the pity. In another twenty-five years the old time Westerner will have gone too—gone with the buffalo and the antelope. I'm going to hand down to posterity a bit of the unadulterated real thing if it's the last thing I do—and I am going to do it muy pronto."

Dunton, throughout his life, enjoyed the role of outlier. He was an outdoorsman devoted to hunting and sketching in the wilderness. His work was distinguished by a sense of integrity, a devotion to authenticity, and a love for the land and the people he painted. During his lifetime he achieved great success in his career as an illustrator, and he was one of the six founders of the Taos Society of Artists.

Oil. 16⅛ × 12⅛ in.

142

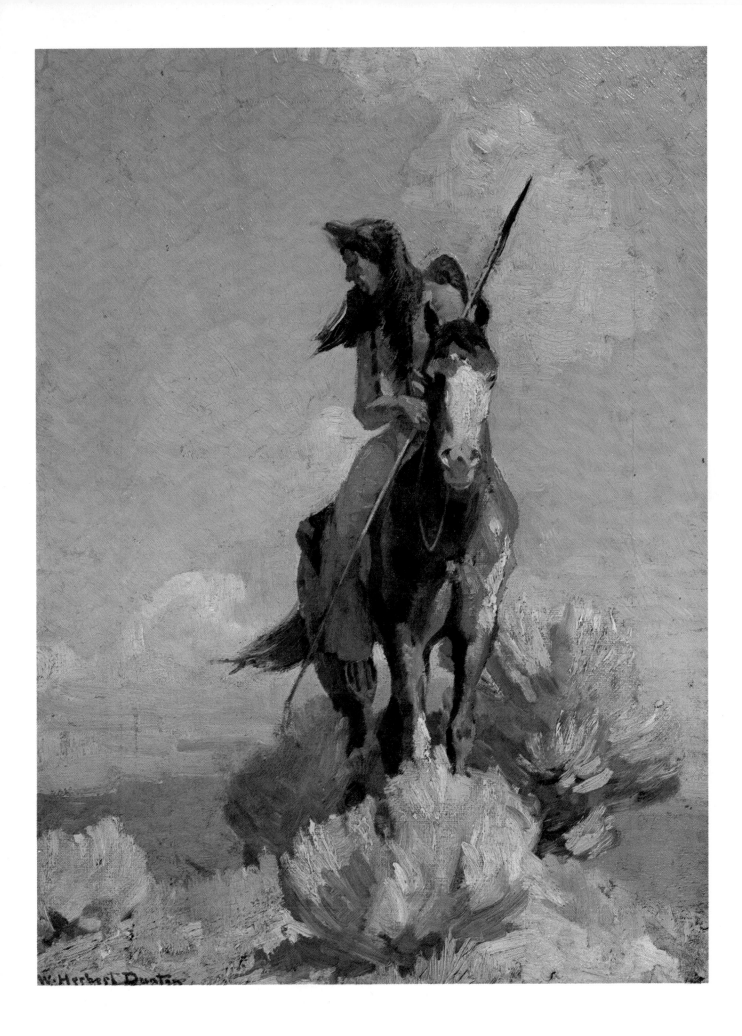

Walter Ufer (1876–1936)

HUNGER

IN *HUNGER*, WALTER UFER UTILIZED the theme of crucifixion and the religious images of the Penitente people of New Mexico to protest the conditions of deprivation and misery that followed World War I.

The Penitentes, zealous religious mystics living in the mountains, endeavor to purge their souls of sin by rites of repentance. Such rites include prolonged fasting, self-abnegation, and physical suffering. They conduct their religious rites in secret in a windowless building called a *moradas*. The act of purification includes flagellation with cactus. In the past the Penitentes have even reenacted the crucifixion.

In *Hunger*, Ufer has painted the Penitente crucifix, which represents the ultimate submission to suffering, humiliation, and pain. The Christ figure is one of weakness and impotence rather than one of strength and power. Christ absorbs and reflects, rather than assuages, the suffering of the people prostrate before him. The Madonna appears as a rigid icon. Ufer's Madonna is not the warm mother of mankind, a humane figure of love and consolation, but a symbol of suffering in the world. An isolated figure, she stands upright, a strange pillar of faith and endurance, in stark contrast to the bent forms of the worshipers. The worshipers appeal not to this Madonna but directly to the crucified figure that shares, rather than relieves, their misery.

Ufer's painting can be seen as a parable of the postwar world in which man has turned against man, creating spiritual and physical deprivation. Man has been martyred by the ravages of war. The people suffer spiritual and physical hunger, but martyrdom cannot relieve their misery. Only the church mouse in the corner of the painting represents life and the spirit of survival. It is through action and dedication to the living, rather than through self-immolation and supplication, that hunger can be overcome and humanity can be renewed in the world.

Walter Ufer settled in Taos in 1914 when he was thirty-seven years old. *Hunger* stands in contrast to Ufer's best-known works—bright canvases of the sunlit world of the Indians of New Mexico.

Oil. 50½ × 50¼ in.

Robert Henri (1865–1929)

GREGORITA

ROBERT HENRI TRIED IN HIS PAINTINGS to express the spirit of American life. Henri was the leader and spokesman of The Eight, a group of artists who rejected the sentimentality and traditional aestheticism of Victorian academic art. Instead they tried to express in their work the experiences of daily life in an industrial society.

The central theme of Henri's theory of art was "art spirit," the expression of the vitality of life through art. During World War I, Henri visited Santa Fe and Taos and recognized the art spirit in the life and creativity of the Indian people.

While in New Mexico, Henri painted portraits of several Mexican and Indian people. He tried to paint his personal response to his subjects and express in his portraits the essence of life in the Southwest. Henri wrote: " . . . I was not interested in these people to sentimentalize over them, to mourn over the fact that we have destroyed the Indian. . . . I am looking at each individual with the eager hope of finding there something of the dignity of life, the humor, the humanity, the kindness, something of the order that will rescue the race and the nation. That is what I have wanted to talk about and nothing else. The landscape, the houses, the workshop of these people are not necessary. I do not wish to explain these people, I do not wish to preach through them, I only want to find whatever of the *great spirit* there is in the Southwest." In his portrait of Gregorita, a woman of the Santa Clara Pueblo, Henri achieved his artistic goal.

Oil. 36 × 26 in.

146

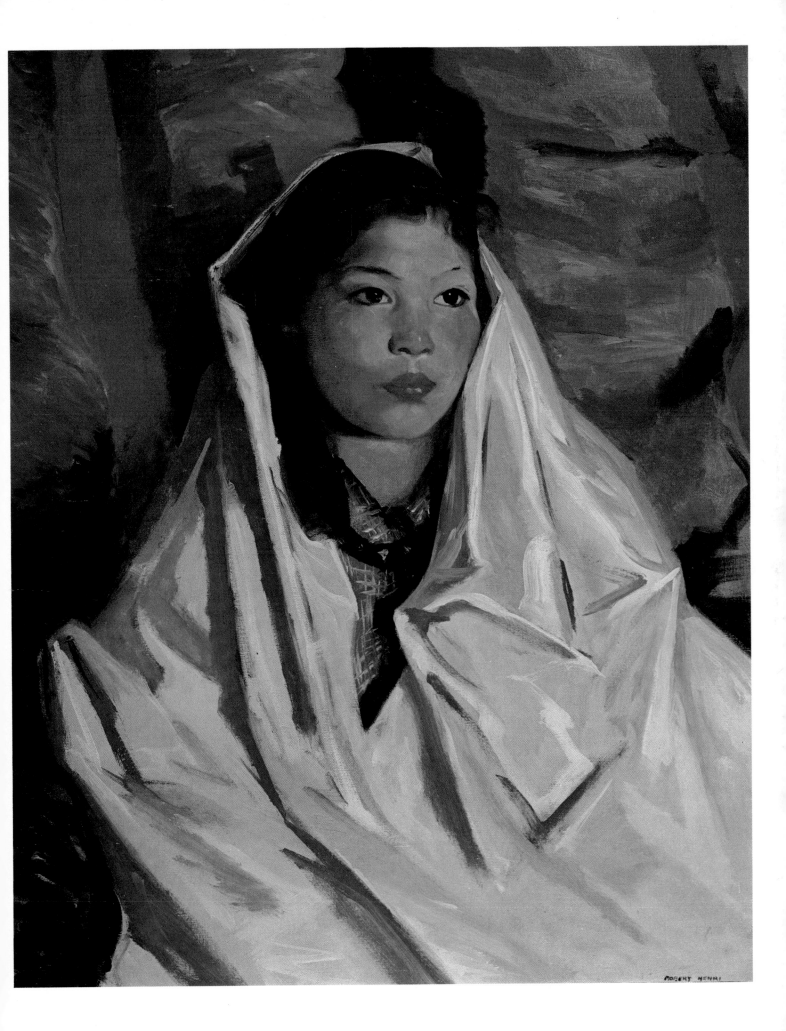

Fred Kabotie (b. 1900)

BASKET THROWING

THE BASKET DANCE, OR LACON, is performed in October as an important ritual of the ceremonial year. During the Lacon, which is a harvest celebration and a form of preparation for the coming winter, the women throw corn at a corn-husk wheel. The Hopi women celebrate the harvest of the crops they helped to grow through their prayers, and they pray for an abundance of wild game for the Hopi hunters. All Hopi women are members of the Mumzoid, the Women's Society that performs women's dances—the Lacon Dance and the Knee-High Dance.

Each year during the Lacon ceremony, several young Hopi women are confirmed as basket weavers. Basketry is a craft that represents the cycle of life from birth to death. Basketry is the oldest Hopi craft art. For centuries the Hopi have hand manipulated natural plants and grasses to create useful and decorative baskets and plaques. In ancient days Hopi men were also skilled in basketry, but today it is purely a woman's craft. The role of a woman in the Hopi world is one of great importance. The Hopi woman is looked upon with both respect and reverence. The mother is the head of the household, and the children take their clan identity from her. A female child is particularly desirable, for she will perpetuate her clan. Childbearing is a sacred duty, for only through regeneration—creation of a new life—can the Hopis survive on Earth. In Hopi society both husband and wife have mutual obligations; however, each retains personal independence.

Fred Kobotie is the first Hopi painter to receive individual recognition as an artist. In 1918, he was one of the seven original students of Elizabeth de Huff at the United States Indian School in Santa Fe. Kobotie returned to the Hopi mesas to live according to the beliefs and tenets of his people and to teach the young the fundamentals of painting. For almost sixty years Kobotie has been an active participant in the ceremonial life of the Hopis, and he has worked to achieve and maintain the highest standards of Hopi arts and crafts.

Watercolor. 11 × 14 in.

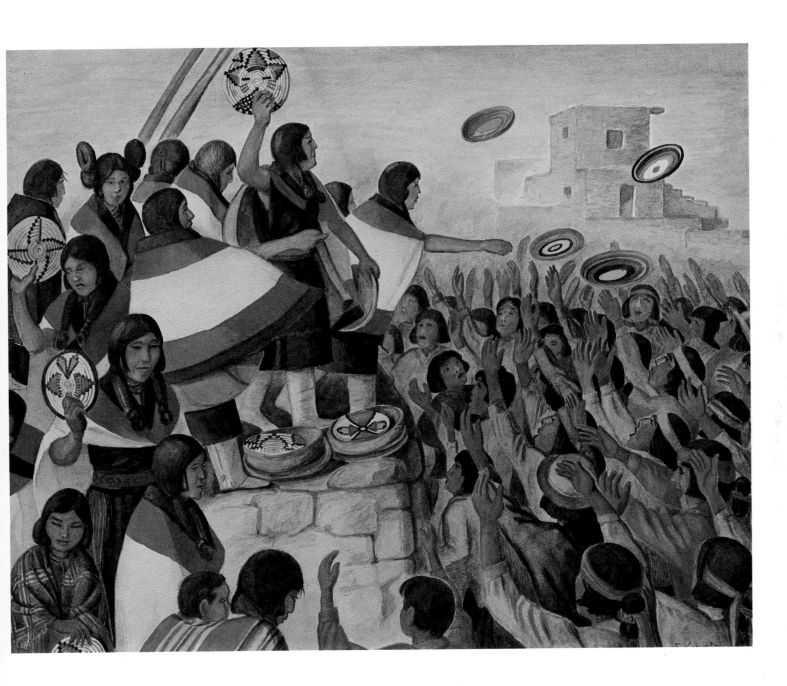

Waldo Mootzka (1903–c.1935–40)

FERTILITY

WALDO MOOTZKA WAS ONE of the first twentieth-century Hopi artists to depart from the tradition of painting documentary likenesses of individual Kachinas, lines of Kachina dancers, or narratives of Kachina ceremonies in order to paint the visions inspired by his religious beliefs. Until the end of the nineteenth century, all Hopi paintings were an integral part of religious ceremonies. Those with artistic skill painted Kachina masks, *tablitas,* altar screens, and ceremonial murals on the walls of the kivas, underground ceremonial chambers. The paintings of the first generation of Hopi artists to be influenced by the standards of white men were anthropological and educational in focus, and they set the standards for several generations of Hopi painters.

Mootzka returned to the centuries-old Hopi tradition of painting the primary theme of Hopi life and art—the never-ending renewal of life, the cycle of fertilization, germination, growth, harvest, and regeneration.

In *Fertility,* Mootzka simultaneously portrayed the fertility rights for the corn crop and the fertility rights for the propagation of the Hopi people. Each image in this painting symbolizes the power of germination and the generative force central to Hopi life. All the figures are suspended above stylized cloud and rainbow forms, which are symbols of the rain and the life-giving powers of rain. A Hopi man kneels on the rim of the sun before a Hopi woman, who carries a stalk of corn in each hand. The torch-bearing maidens are Corn Spirits. The Hopi think of corn as their Corn Mother, for corn was given to them as the principal source of food. They draw life from the corn as the child draws life from its mother. The Hopi see the sun as the father of life, and the combination of sun and corn is a familiar iconographical pattern in Hopi painting.

The Hopi believe there is a spiritual essence in all matter. There is a fixed order in both the natural world and the supernatural world. All spirits must be in harmony with this order before life can continue smoothly, crops can flourish, and the Hopi can share in universal progress. Mootzka's painting is a visual prayer for universal harmony and regeneration of life on Earth.

Watercolor. 15½ × 11⅛ in.

Acee Blue Eagle (1907–1959)

CREEK WOMEN MAKING SOFKY

I<small>N</small> *C<small>REEK</small> W<small>OMEN</small> M<small>AKING</small> S<small>OFKY</small>*, Acee Blue Eagle, a Creek-Pawnee, depicted one of the domestic duties of the Creek women after their resettlement in the Oklahoma Territory. For ten years after the congressional act of May, 1830, the United States removed the Creek, Choctaw, Seminole, Chicasaw, and Cherokee tribes to Indian Territory. Today this region is the state of Oklahoma. The forced migration of these tribes is known as the Trail of Tears, a tragic ordeal in which the Indians faced deprivation, disease, and death. The tragedy of the Trail of Tears is the central theme of the paintings of many Oklahoma Indian artists.

In 1830 the Creek signed a treaty that ceded all tribal lands east of the Mississippi to the United States. In this treaty the government promised that no Creek would be compelled to emigrate "but they shall be free to go or stay as they please." The government did not honor this provision, however, and a period of conflict and struggle between the Creek and the United States government followed. In 1836 General Winfield Scott set out to end the Creek War and forcibly removed 14,609 Creek, of whom 2,495 were enrolled as hostiles. With their chiefs chained and handcuffed, most Creek walked overland under military escort. Over 3,500 of these emigrants died from exposure and fever.

Sofky is a hominy that was made by pounding the hard shelled corn (flint corn) in a mortar. The women used a pestle, a club-shaped hand tool, to pound the corn, then poured water over wood ashes to make a lye, which they added to the mashed corn. The Creek drank the juice and ate the hominy.

Rather than portray the hardships and miseries of the ordeals of the Creek people, as they worked to rebuild their community in Indian Territory, Acee Blue Eagle painted a tranquil domestic moment. Blue Eagle's painting pays tribute to the strength and fortitude of the Creek people, who survived great hardships and reestablished their nation in a new land.

<div align="center">Tempera. 26 × 11½ in.</div>

Woody Crumbo (b. 1912)

ANIMAL DANCE

In *Animal Dance*, Woody Crumbo pays tribute to the spirit of brotherhood between Man and Animal in the Indian world. Crumbo is a member of the Potawatomi tribe of Oklahoma, a tribe related to the Chippewa and the Ottawa. Historically the three tribes were one tribe living on the shores of Lake Huron. Crumbo has painted a mixed animal dance, a hunting ritual performed by the Potawatomi in the 1800s. This dance was performed in the Spring to bring good luck to the hunters and in the Fall to offer thanks for a season of good hunting.

Crumbo has painted the autumn animal dance in which the Potawatomi enacted the roles of both the hunter and the game. Those dancers who represent the animals wear full animal skins. The hunters carry shields, bows and arrows, and staffs, and they wear elaborate eagle-feather head-dresses, which signify participation in many hunts. A tripod supports a medicine bundle and prayer feathers. Behind the dancers are poles, on which there are masks known as "bad faces." These masks protect the hunters and provide good luck. On the central post is the head of a buffalo, and it serves as a eulogy to the buffalo. At the foot of this central post and on each side are altars dedicated to the buffalo. These altars are expressions of the honor and respect that the Potawatomi feel toward the buffalo, their brother.

Crumbo was born on his mother's share of the Potawatomi allotment (the portion of land given by the United States government to each member of the tribe) in Lexington, Oklahoma. His painting celebrates the Potawatomi belief in animals as kindred beings who must be honored and respected, though it is necessary to kill them to obtain basic necessities. After the hunt it is especially important that the Indians honor the animals killed by performing a dance and offering prayers, which express their appreciation to the animals and their sorrow at having had to kill them. The Potawatomi pray that the animal spirits will journey to the next world, where it will no longer be necessary for man to kill his brothers.

Tempera. 44½ × 25 in.

Jose Ray Toledo (b. 1915)

PUEBLO CEREMONIAL (SHALAKO)

THE SHALAKO DANCE, A WINTER DANCE at the Zuni Pueblo performed from sundown until sunrise, is one of the most colorful Pueblo ceremonies. The night of the Shalako Dance and the following day are the culmination of the forty-nine-day reenactment of the story of the Emergence (arrival on the earth) and Migrations (search for their sacred home) of the Zuni people. During the Shalako ceremony the spirit of the Dead returns to the Pueblo to be honored.

The Shalako Dance is an important prayer ritual for the health, happiness, fertility, and long life of the Zuni people, and the propagation and regeneration of plants and animals. The nocturnal dance is a blessing for houses built or remodeled at the Pueblo that year. There are usually eight houses—six Shalako houses, a Longhorn house (for the Council of the Gods) and the Koyemshi (Mudheads) house.

On the following day the Shalakos compete in races that depict the Shalakos delivering messages and prayers, which ask for rain. If a Shalako falls, it is an omen that a bad year will follow. After the Shalakos depart, the young Zuni men try to catch the giant spirits, a ritual enacted to ensure success in hunting deer.

Shalakos are ten-foot-tall Rain Spirits, and they are messengers for Zuni prayers. Two Zuni dancers alternate in carrying the huge mask of the Shalako, which is supported by a pole. The Shalako is a rain-making and life-giving spirit, and the eagle-feathered headdress signifies the power of flight, for flight enables the prayers of the Zuni to reach their intended destination. The Shalakos have flat turquoise faces and long birdlike beaks. They wear elaborate jewelry and a double tier of Hopi kilts supported on hoops. The kilts are decorated with water scrolls, lightening bolts, terraced clouds, and other rain symbols. The Shalakos dance like giant birds, clacking their beaks and making whistling sounds.

Jose Ray Toledo finds his inspiration in the rituals of the Jemez Pueblo where he lives and in the ceremonies of the neighboring pueblos. Through his paintings, Toledo gives visible expression to the spirituality of the Indian people.

Watercolor. 25¼ × 19¾ in.